Cuom

America's Sexiest Governor

Drumpf House **by Melania**

ISBN: 978-1-0878-9832-2

Published by Drumpf House Publishing
New York, New York.

The artwork in this publication was created using a
collage of digital photography and hand drawn art

drumpfhousepublishing@gmail.com

about this book

This book is satire. If you have your own little, or maybe overwhelmingly enormous crush on the responsible, dependable, reassuring, sweet Governor Andrew Cuomo, you are in good company. Or maybe you just think the growing heartthrob status of a civil servant in his sixties is a riot. Can a man become a sex symbol by virtue of his honesty, data informed decision making, and open love for his mom, his brother, meatballs, and the state of New York?

about the author

Melania is a wife, mother, and living example of the promise of America to immigrants. Growing up under communism in Eastern Europe, she made her way to New York as a young adult eventually gaining citizenship and making a name for herself in fashion, business, and politics. She developed a quarantine crush on the Lov Gov as he rose to meet the needs of his people where other leadership left her... dissatisfied.

Though my tower is draped in gold and fine furnishings, I felt trapped like a modern day Rapunzel. My husband, as has become his habit, went into a state of denial and nonsensical ramblings. Scared and alone in confronting a new and unsettling existence, I sought a harbor from the storm. Just as a dark hopelessness began to descend into my soul, I was saved as the words of my true prince burst forth from the wifi. *Love wins, always.*

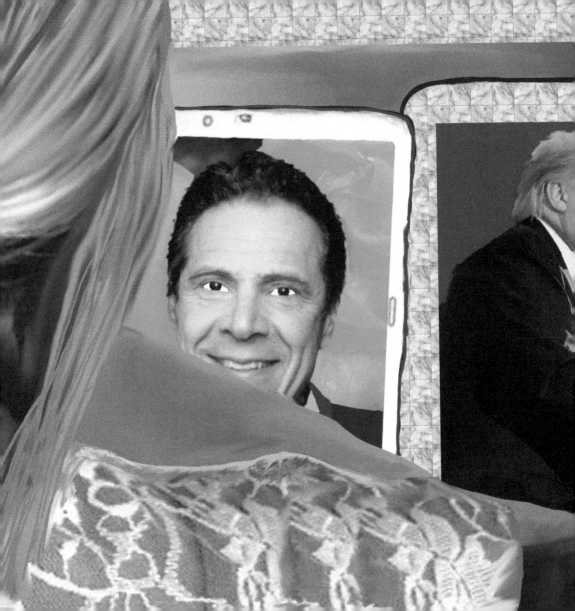

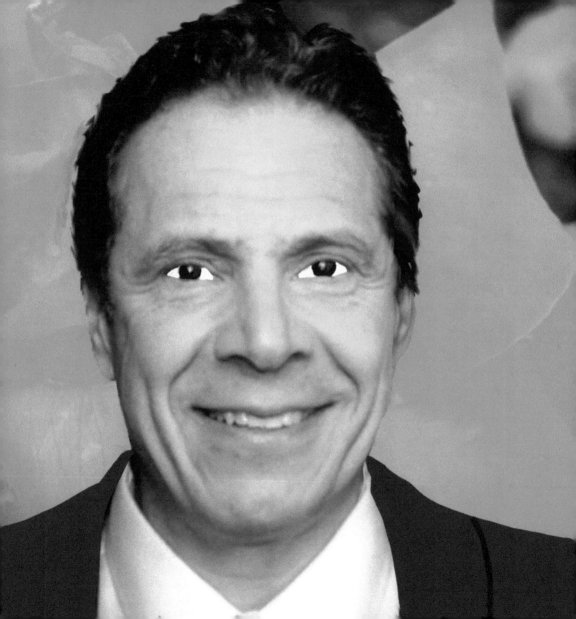

Is it his

mocha eyes?

Or is it his hair, **thick**, **dark**, and **lovely** even on the windiest day?

Curve

His impressive use of data and charts?

The sheer
masculinity of
a man who
isn't afraid to
**talk about
love?**

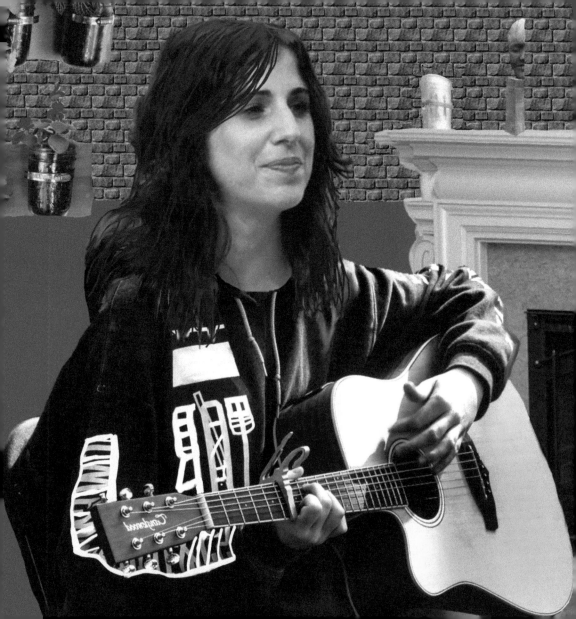

Alone in our homes, **Cuomo Fever** runs hot as we await **you**.

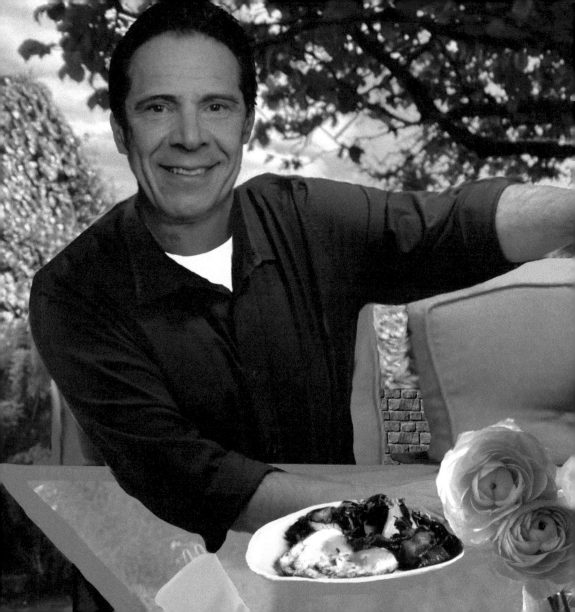

I've always longed for a man who takes care of himself...

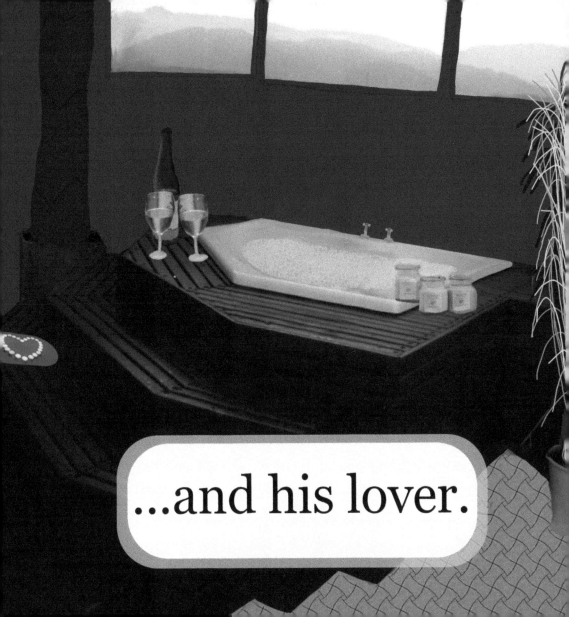

...and his lover.

Whisk me away
on an adventure.
I'm ready to ride.

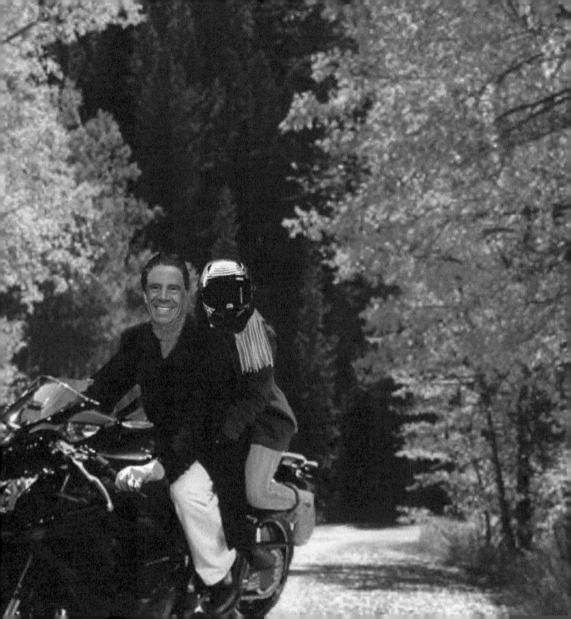

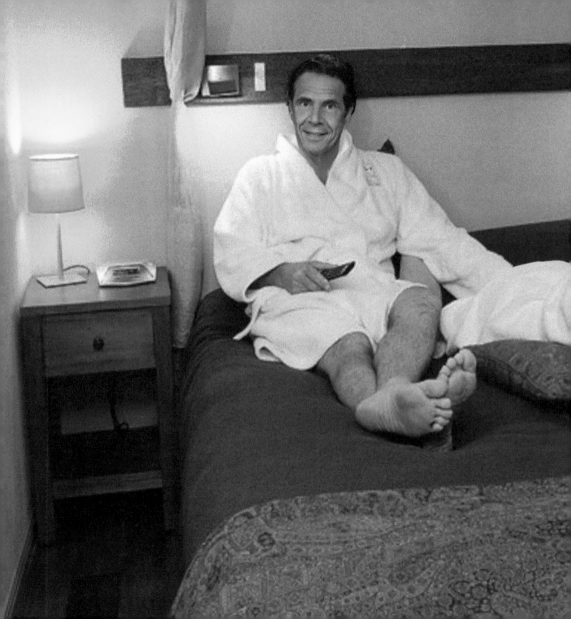

To a romantic escape, where we can relax at the end of the day. Even if it's a very long day, we know how our story ends. **Love wins. Always**.

Cuomo*hh*meter:

Answer the questions below to determine your cuomosexuality status. As with all matters of human sexuality, cuomosexual tendency exists on a spectrum and an individual's status can shift over time.

Which of the following would cause you to miss a live press conference with the Lov Gov?
a) Work meeting.
b) Husband has been in an accident.
c) You are unconscious.

Was there a time when you considered 11:30 am to be a standard lunch date with your boyfriend?
a) Um no, why?
b) Yes, but I'm not sure that he feels the same way.
c) Yes, that's *our time.*

Did it take you a while to shake off the sadness when Cuomolicious announced he would no longer be giving daily press conferences?
a) No, I have Netflix.
b) Yes, I felt lost. Sometimes I still do.
c) Yes, but I fill the void with press conference replays.

Do you watch recorded press conferences of the Lov Gov?
a) No, I can always catch the recap on the nightly news.
b) Yes, if I can't give it the proper attention when it's live.
c) Yes. I always like to listen to his soothing data in bed.

When viewing Cuomolicious, have you ever lied to someone you care about regarding your activities?
a) No, it's not that serious.
b) Yes, the people I live with just don't understand.
c) Yes. Our relationship is confidential.

How does your significant other feel about your relationship with the Lov Gov?
a) Hasn't noticed.
b) Considers it cute and funny.
c) Date night for us is listening to classic press conferences while sharing a bottle of red.

Do you sometimes hide the amount of time you spend looking for Cuomo-info?
a) No, I really just check the headlines.
b) Yes. I tell them I'm working but I'm really swooning.
c) Yes, and I'm concerned I may be flagged as a security risk based upon my search history.

Are you in a committed relationship, but you announce publicly that you are in love with Governor Cuomo?
a) I save my public declarations of love for Dr. Fauci.
b) Yes, but my significant other thinks it's funny.
c) Yes, and my significant other has brought this up with our therapist.

Have you considered a road trip to Albany just to see if you could bump into Cuomy at the Governor's mansion?
a) I'm more of a Poconos vacation type of person.
b) No, but not a bad idea!
c) Planned the trip and ordered the travel toilet since public bathrooms are hard to come by.

Are Andy's eyes brown, or hazel?
a) Not sure.
b) I think they're brown.
c) I'm really on the fence on this one. During the press conferences I see a deep mocha, but when he's on the beach they seem to reflect a bit of green from the ocean.

What feelings do you have when Governor Cuomo puts on a mask?
a) Relief that there is responsible leadership in Albany.
b) Excited to be a part of his team. I really wish he could see me in my mask too!
c) I start thinking about playing doctor.

How do you feel about Melissa?
a) Who is she?
b) A little jealous, sometimes I wonder if their relationship is completely professional.
c) I've been keeping tabs on her.

Do you own any Cuomo swag?
a) Cuomo swag is a thing?
b) I ordered the T-shirt.
c) I have created a custom mask to show my support and love for The Great One.

What is your relationship with the Mario Cuomo Bridge?
a) You mean the Tappan Zee?
b) I cried when it opened.
c) I feel a deep sense of belonging to the family when I cross the bridge, which I do often.

Tell me about photos of our Lov Gov.
a) I enjoyed the Cuomo family photos in *People Magazine*.
b) I framed the *People Magazine* issue featuring the Lov Gov.
c) I have a photo of Andy in my wallet.

What private names do you have for Cuomy?
a) Excuse me, what?
b) Lov Gov, Boo, or Baby.
c) Daddy.

When Cuomy says "New York Loves You" during a public address, how do you feel?
a) Reassured that there is leadership looking to unite us.
b) New York loves you back Lov Gov!
c) He is talking directly to me.

How do you feel about Andy's public speaking?
a) It's refreshing to hear honesty and reliance on data.
b) He has so many great one-liners, I just love him.
c) I'm strangely aroused by the way he pronounces *Covid-19*.

How does Cuomy fit into your social media activity?
a) I've shared a few news items.
b) I click around daily looking for exciting Cuomo-info.
c) Sometimes I post something in a Cuomolicious fan group that is so naughty, I get nervous that someone I know in real life might somehow see it.

How curious are you about Governor Cuomo's personal life?
a) Aren't we socially isolating?
b) I follow.
c) I wonder what he smells like.

What kinds of topics do you discuss in therapy?
a) I have some anxiety about national instability.
b) We talk about my tendency to seek relationships with unavailable men.
c) The stress of planning a wedding with a public figure, and this is during a couples' therapy session with my starter husband.

What kind of videos do you enjoy on Tik-Tok?
a) I just nearly choked watching the one of the twins pretending to blowdry Trump's hair.
b) I've seen some pretty hysterical ones made by Cuomo's fans.
c) I am a top contributor of adult themed videos featuring my fantasies with the Lov Gov.

How do you feel about Michaela, Cara, and Mariah?
a) Sorry, I know a lot of people, can you give me more information?
b) His love for them makes me love him even more.
c) My step-daughters? They are just so fabulous!

When Governor Cuom-ohh is being treated unfairly during an interview, what do you do?

a) I change the channel.

b) Seeing how he handles himself with both humility and confidence is a major turn on.

c) The only interviews worth watching are done by Chris. I have a fantasy of putting myself right in between those naughty brothers.

Cuom*ohh*meter Results:

Mostly a: **Acuomosexual**- While you may have a strong enough moral compass to support and admire the luscious Governor Andrew Cuomo, your lukewarm enthusiasm suggests you have few cuomosexual tendencies.

Mostly b: **Cuomocurious**- You can sense on a primal level that there is something unique and seductive about America's sexiest governor. Explore your impulses, get in touch with new feelings. If the mood strikes you, join cuomosexuals worldwide in proudly flying the cuomosexual flag.

Mostly c: **Cuomosexual**- Your passion for the Lov Gov's peerless sexual magnetism has been unleashed in your conscious mind. Governor Cuomo's secure masculinity, free expression of love, his embrace of science and every member of the community, coy smile and tantalizing voice come together to create the man who drives us to distraction. Still single for now, may the most seductive comosexual win his heart.

Share The Love!

Many thanks to my readers, we are stronger together!

I need your help to spread the love.

Your review of this book at your favorite online bookstore will help other Lov Gov admirers find their tribe.

Please share this book on social media, and with friends and family who are on the brink of a cuomosexual awakening.

Love Always Wins,

Melania

Props

Scenery

Characters

"Mom an' Dad" by Teeejayy
"Singing in Brisbane Mall-3=" by Sheba_Also 43,000 photos
"File:Andrew Cuomo January 2016.jpg" by MTA
"File:Andrew Cuomo at March For Our Lives rally.jpg" by Er-nay
"File:Andrew Cuomo 2016 crop.jpg" by Metropolitan Transportation Authority of the State of New York
"LGBT PRIDE PARADE 2013" by lazerCam
"File:Carl-F.-Mattone-Hon.-Andrew-Cuomo1 (10215820794).jpg" by Carl Mattone
"2016 NYC Pride Parade" by Steven Pisano
"File:Andrew Cuomo 2014 (cropped).jpg" by Andrew Cuomo by Diana Robinson.jpg: Diana Robinson derivative work: 12anonymoususer34
"File:Inaugural ride of the Second Avenue Subway (31224282093).jpg" by Metropolitan Transportation Authority of the State of New York
"SAS_1419" by MTAPhotos
Andrew Cuomo by Pat Arnow.jpeg: Pat Arnow derivative work: UpstateNYer
"Sandy Resiliency Tour" by MTAPhotos
"St. Patricks Day" by Tom Hannigan
"File:Inaugural ride of the Second Avenue Subway (31193357844).jpg" by Metropolitan Transportation Authority of the State of New York
"sexting again" by lyndawaybi3
"Playing Guitar in Brisbane Queen St Mall-2=" by Sheba_Also 17,000,000 + views
"St. Patricks Day" by Tom Hannigan
"St. Patrick's Day Parade NYC 2016" by Rich.S.
"IMG_8491.JPG" by jsmjr
"Cross Body Dumbbell Hammer Curl" by personaltrainertoronto
"Blue Eyes (280 / 365)" by somegeekintn
"Paul and his domestic duties" by shelleylyn
"Lynfred Wheeling Anniversary Weekend 3" by H. Michael
"Iowa City, IA" by Alan Light
"Photographing Hunky Jesus" by Chris Hunkeler
"Wicker Hair Lifestyle: Blonde Blast To emphasize this beautiful blonde hair, the color of the clothing was muted out! Shared by wickerparadise.com" by Wicker Paradise
File:Andrew Cuomo 2017.jpg by Metropolitan Transportation Authority / Patrick Cashin

GEORGY ZHUKOV

LEADERSHIP ▪ STRATEGY ▪ CONFLICT

ROBERT FORCYZK ▪ ILLUSTRATED BY ADAM HOOK

First published in 2012 by Osprey Publishing
Midland House, West Way, Botley, Oxford OX2 0PH, UK
44-02 23rd St, Suite 219, Long Island City, NY 11101, USA

E-mail: info@ospreypublishing.com

Print ISBN: 978 1 84908 556 4
PDF e-book ISBN: 978 1 84908 557 1
EPUB e-book ISBN: 978 1 78096 044 9

Editorial by Ilios Publishing Ltd, Oxford, UK (www.iliospublishing.com)
Cartography: Mapping Specialists Ltd.
Page layout by Myriam Bell Design, UK
Index by Marie-Pierre Evans
Originated by PDQ Digital Media Solutions, Suffolk, UK
Printed in China through Worldprint Ltd.

12 13 14 15 16 10 9 8 7 6 5 4 3 2 1

A CIP catalogue record for this book is available from the British Library.

www.ospreypublishing.com

Artist's note

Readers may care to note that the original paintings from which the colour plates in this book were prepared are available for private sale. All reproduction copyright whatsoever is retained by the Publishers. All enquiries should be addressed to:

Scorpio Gallery, PO Box 475, Hailsham, East Sussex, BN27 2SL, UK

The Publishers regret that they can enter into no correspondence upon this matter.

Front-cover image credit

Corbis

The Woodland Trust

Osprey Publishing are supporting the Woodland Trust, the UK's leading woodland conservation charity, by funding the dedication of trees.

Acknowledgments

I wish to thank Nik Cornish and RIA Novosti for their help with this project.

Dedication

In remembrance of 1LT Salvatore S. Corma, A/2-508 IN, 82nd Airborne Division, died of wounds in Zabul Province, Afghanistan, 29 April 2010.

Glossary

Military District (MD)
Komandarm – Army commander
Komkor – Corps commander
Komdiv/Nachdiv – Division commander
Kombrig – Brigade commander
RKKA – The Workers' Peasants' Red Army
GA – Guards Army
GTA – Guards Tank Army
NKVD – Narodnyj komissariat vnutrennikh del
GKO – State Defense Committee (Gosudarstvennyj komitet oborony)
RVGK – Reserve of Supreme High Command
AOK – Armeeoberkommando (Army)
CPSU – Communist Party of the Soviet Union

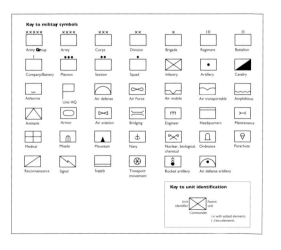

CONTENTS

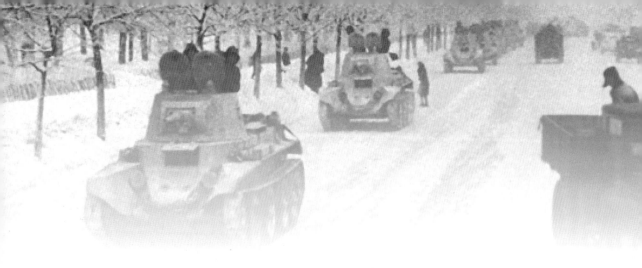

INTRODUCTION

When the German Wehrmacht invaded the Soviet Union in June 1941 its leaders did not realize that they were embarking upon a four-year-long fight to the death. The Red Army appeared feeble after the Stalinist purge of its officer corps in 1937–39 and the botched Soviet invasion of Finland suggested gross organizational incompetence. Adolf Hitler confidently expected the blitzkrieg to cause a rapid collapse of the Soviet state, as had happened to the Wehrmacht's earlier victims. Yet despite early, crushing battlefield victories the Wehrmacht could not destroy the Red Army's will to resist. Part of the ferocity of Soviet resistance was based upon the ironhanded tyranny of Josef Stalin that made surrender unthinkable, as well as the Communist Party's ability to motivate its citizens through nationalistic propaganda and terror. However these factors could only delay defeat; in order to win, the Red Army had to demonstrate the ability to conduct successful offensives in order to drive out the hated invaders.

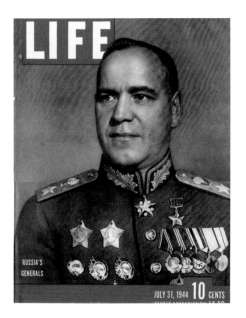

Zhukov on the 31 July 1944 edition of *Life* magazine. Zhukov became the official face of the Red Army in World War II and one of the few Soviet generals recognizable in the West. (Author)

In a conflict of this scale, involving armies of millions, the role of individuals seems secondary and perhaps even irrelevant. Certainly on the German side there were a number of significant high-level commanders, including Bock, Kluge, Manstein and Rundstedt. Yet Hitler allowed his commanders to conduct only operational-level warfare and arrogated strategic decision-making to himself alone. Consequently, despite their individual talents, none of the senior German commanders on the Eastern Front emerged as *primus inter pares* and Hitler regarded each in turn as expendable. In contrast, on the Soviet side, Marshal Georgy Zhukov was unquestionably the dominant figure in the Red Army throughout the entire period of the Russo-German conflict. Although frequently rotated between command and advisory roles, Zhukov provided the backbone of the Red Army's efforts during the desperate defensive actions of 1941–42 and it was he who played a critical role in orchestrating the Red Army's ability

to conduct successful multi-front offensive operations that ultimately determined the military fate of the Third Reich.

After the Stalinist purges, Zhukov was the only surviving Soviet senior commander with the battlefield competence, political reliability and leadership abilities to command effectively large formations against the best that Germany had to offer. Serving as a senior General Staff representative from the Stavka, Zhukov moved from one critical sector to the next, acting as adviser, coordinator and de facto front commander as required. There is no doubt that Zhukov played a critical role in salvaging the Soviet situation in the autumn of 1941 and leading the Red Army to an amazing reversal of fortunes in 1942–43 and eventual victory in 1944–45. Zhukov demonstrated an immense talent for detailed planning and the ability to coordinate very large armies in complex operations. Although not a great military theoretician himself, Zhukov resurrected elements of the 'deep battle' doctrine developed by the Red Army during the 1930s and gradually moulded it into a war-winning methodology in 1943–45.

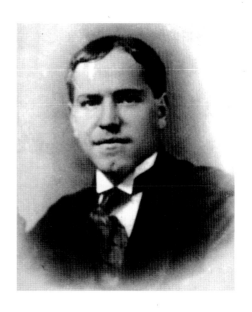

Zhukov as an up-and-coming bourgeois in early 1914. Having settled into a steady trade in Moscow, the 17-year-old Zhukov had little desire to volunteer for army service. Unlike many of his later peers in the Red Army, such as Konev, Meretskov and Vatutin, Zhukov came from a non-peasant background. (Author)

Yet as a commander, Zhukov suffered from flaws that bring his inclusion into the ranks of the 'Great Captains' into question. His operational methods were often brutal, contributing to massive Soviet casualties. Nor did he demonstrate much loyalty or affection either for his subordinate commanders or the common Soviet soldier. Zhukov became the most recognized Soviet commander in World War II because he made a conscious effort to grab the limelight for himself and minimize the role of his military peers. Zhukov's complex relationship with Stalin was also a major determinant of his role in World War II – his stock was at his highest in the Soviet Union's hour of crisis but Stalin later began to regard a military hero as a threat to his own authority. Once the war was over, Zhukov's post-war fall was just as rapid as his initial rise in the Red Army and it was not until the collapse of the Soviet Union that his reputation was restored.

THE EARLY YEARS, 1896–1914

At the end of the 19th century the Zhukov family lived in obscurity in the village of Strelkovka, 50 miles (80km) south-west of Moscow. Konstantin A. Zhukov was a 50-year-old cobbler in the town. Although Georgy Zhukov would later claim a peasant origin in order to conform to Communist ideals, it would be more accurate to describe his family's social standing as tradesmen. On 2 December 1896, Georgy Zhukov was born. A daughter was born in 1898 and another son in 1901, but Georgy and his sister Masha were the only two to survive childhood.

Georgy Zhukov was brought up in a financially austere environment with limited education and an emphasis on physical labour. He attended a nearby village school for three years, which provided him with basic literacy. During this period, his father had gone to Moscow to seek more work but made the mistake of joining a street protest amidst the Revolution of 1905, which got him permanently banned from the city. Instead, the 11-year-old Georgy was sent to Moscow in mid-1908 to work as an apprentice furrier with his maternal uncle, who had amassed a small fortune. At age 11, Zhukov gained his first exposure to the wider world. His uncle provided him with a regular income that was double what farm labourers earned but also frequent beatings, which hardened the youth. Georgy spent a total of seven years working as a craftsman in Moscow and was there when World War I began in August 1914.

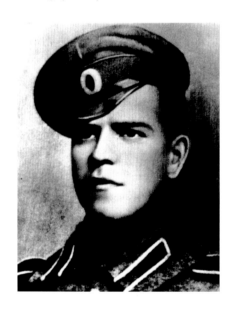

Zhukov as a 19-year-old cavalryman in the 10th Novgorod Dragoons, just before he saw his first action in the closing stages of the Brusilov Offensive. Aside from a brief glimpse of combat, the main thing that Zhukov learned in the Tsarist Army was attention to spit 'n polish in maintaining his equipment and an automaton-like approach to military training. (Author)

THE MILITARY LIFE, 1915–41

World War I, 1915–17

On 7 August 1915, Zhukov was sworn into service at Maloyaroslavets and assigned to one of the reserve regiments supplying replacements to the 10th Cavalry Division. The Russian Imperial Army put greater effort into training cavalrymen than it did infantrymen and Zhukov spent the rest of the year near Kharkov, learning his basic horsemanship skills. Since he had basic literacy – unlike the peasant conscripts – Zhukov was selected to attend an NCO training course in the spring of 1916, which resulted in his promotion to corporal. After nearly a year of training, Zhukov was finally sent to join the 10th Cavalry Division in the South-western Front in August 1916.

Zhukov arrived at the front in the closing stages of the Brusilov Offensive, which had inflicted enormous damage upon the Austro-Hungarian armies. However, the Germans had rushed reinforcements to the area to prevent a Russian breakthrough and the offensive had degenerated into local actions. Zhukov was assigned to the 10th Novgorod Dragoon Regiment, which fought as dismounted infantry since mounted cavalry was of limited use in the hilly terrain. Zhukov's baptism of fire was brief but momentous; in only a month at the front, he was twice awarded the Cross of St George – once for capturing a German officer and the second time for being wounded by a mine explosion while conducting a reconnaissance mission. Zhukov's combat service in World War I was actually quite brief and he glossed over it in his memoirs. Suffering from concussion, he was sent to recuperate at a hospital in Kharkov and then became ill during the winter of 1916–17, so he spent his final months in the Imperial Russian Army in the rear.

Just as Zhukov rejoined his regiment near Kharkov, word arrived that the Tsar had been deposed and the Provisional Government created. When the soldiers in his squadron decided to form a political committee, Zhukov was elected as its chairman, probably because of his ability to read and write. As chairman, Zhukov decided to take the Bolshevik line and announced that the squadron would not obey the orders of the Provisional Government. After a few months of confusion, the unruly soldiers disbanded the regiment in May 1917 and headed home. However, the Provisional Government took measures to prevent the army from disintegrating and Zhukov found himself on the run as a deserter for the next six months. It was not until three weeks after the Bolsheviks seized power in November 1917 that Zhukov re-emerged in Moscow. He apparently had notions of returning to civilian employment but with the exodus of most nobles and middle class, there was little need for a furrier in the new Moscow. Instead of finding work in Moscow, Zhukov found typhus and he was seriously ill throughout the winter of 1917–18.

The Russian Civil War 1918–21

By the time that he recovered from his illness in the spring of 1918, Zhukov realized that there were few work opportunities in Moscow and little food. On the other hand, the Russian Civil War had begun between the Bolsheviks, who controlled Moscow, and various counter-revolutionary factions. The Bolsheviks had formed the Raboche-Krest'yanskaya Krasnaya Armiya (RKKA, Workers' and Peasants' Red Army) to fight the counter-revolutionaries and were desperately in need of trained soldiers. Accepting that his only marketable job skill was his cavalry training, Zhukov volunteered to join the RKKA in August 1918 and was assigned to the 1st Moscow Cavalry Division. However, it took months to train and outfit the division, so Zhukov spent the winter of 1918–19 near Moscow. It was not until Admiral Aleksandr Kolchak's White forces mounted a major offensive in the Urals and seized the city of Ufa in March 1919 that Zhukov's unit was sent to the front.

Zhukov was involved in the Bolshevik counteroffensive east of the Volga between March and June 1919 and fought in a number of small-scale mounted actions against White cavalry units. In addition to gaining more combat experience, Zhukov began to develop political instincts and he came to realize that Communist Party membership was a vital prerequisite to further advancement, so he joined the party in March 1919. After Ufa was retaken, Zhukov's regiment was sent to crush an armed uprising near Nikolaevsk, on the Volga. In September 1919, another clash with White forces near Tsaritsyn left Zhukov wounded with shrapnel in his hand. Despite the relatively minor nature of the wound, Zhukov was sent home to convalesce and he

Red Army recruits training in Red Square in Moscow, spring 1919. Note the former Tsarist NCOs teaching the recruits to march. Upon returning to Moscow, Zhukov found no civilian employment opportunities but his NCO and cavalry training made him useful to the RKKA. (Author)

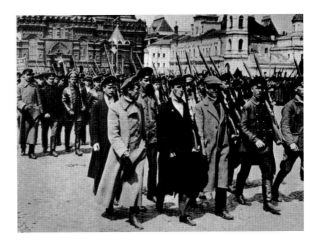

The Red Army was dependent upon 'military specialists' – like these former Tsarist officers who joined the Bolsheviks – for over a decade. Once they were no longer needed, many were eliminated during the purges of the 1930s. Stalin viewed military professionals, no matter how senior or gifted, as expendable assets. (From the fonds of the RGAKFD at Krasnogorsk via Nik Cornish)

spent another winter on the sidelines. Meanwhile, the Red Army was building a powerful mounted strike force in the 1st Cavalry Army (known as Konarmia), under Semyon Budyonny.

After a year in the RKKA, Zhukov had hardly distinguished himself and had spent more time in the rear than at the front. Nevertheless, in January 1920 he was selected to attend a cavalry officer training course in Ryazan and seven months later he was commissioned. In August, Zhukov joined the 14th Separate Cavalry Brigade in the Kuban and participated in mop-up operations against Pyotr Wrangel's retreating White forces. He spent the next four months as a cavalry platoon leader involved in anti-partisan actions and afterwards, he was made a squadron commander.

A simmering peasant rebellion erupted near Tambov in August 1920 and soon grew into one of the largest revolts against Bolshevik rule. A highly decorated cavalry officer, Lieutenant Pyotr M. Tokmakov took charge of the rebel forces and transformed them into an aggressive partisan army that routed several minor Red Army detachments. Zhukov's brigade was hurriedly transferred to Voronezh in December 1920 and he was involved in a sharp action against the partisans on 5 March 1921 for which he was awarded the Order of the Red Banner. Yet it was not until Lenin sent Mikhail Tukhachevsky in June to crush the rebellion with more than 40,000 troops, including Zhukov's brigade, that the rebellion began to fade.

By the end of the Civil War, Zhukov had gained experience in mobile cavalry operations, but mostly against partisans and armed civilians – not regular troops. He was not part of the Konarmia, which was a defining

Red Army cavalry during the Russian Civil War. Zhukov gained extensive experience with cavalry skirmishing and anti-partisan warfare in 1919–22, but little of this was directly relevant to his later command of conventional operations. (Courtesy of the Central Museum of the Armed Forces Moscow via Nik Cornish)

experience for Red Army officers of his generation, particularly since Stalin often demonstrated favouritism to veterans of that formation. Nor had he gained any staff experience during the war and, compared with many of his peers, his service record was rather undistinguished. Having seen only brief front-line service in the closing months of World War I and missed most of the major battles against the Whites and Poles, the suppression of the Tambov Rebellion was the main formative combat experience of Zhukov's early military career.

Red Army Service 1922–38

Zhukov spent most of the inter-war period between 1922 and 1938 among a very small circle of cavalrymen in the Byelorussian MD. Much of his time was spent in the 7th Cavalry Division, commanding a squadron for nine months, then three months as deputy regimental commander before being given command of the 39th Cavalry Regiment in April 1923. Zhukov commanded this regiment for the next six years, even when away at training courses. He gained a reputation as a demanding commander with an explosive temper and a keen eye for polished boots; his memoirs indicate that he was focused on gaining the attention of his superiors. With his wife's tutoring, Zhukov managed to improve his rudimentary reading and writing skills and the party decided that he was ready to attend the Higher Cavalry School in Leningrad in the autumn of 1924. Zhukov spent a year in Leningrad and his classmates included Andrei Eremenko and Konstantin Rokossovsky. However, Zhukov's first decade in the Red Army gave him a very limited view of military affairs and it was not until he was sent to the prestigious Frunze Military Academy in Moscow in 1929 that Zhukov was exposed to any modern military theories or doctrinal discussions.

When Zhukov arrived at the Frunze, the Red Army was just beginning to consider mechanization and forming large tank units. Vladimir Triandafillov, chief of the Operations Directorate of the General Staff, was in the process of developing a new offensive doctrine known as 'deep battle' and Stalin's implementation of the First Five Year Plan enabled the nascent Soviet industrial base to begin indigenous production of tanks. Mikhail Tukhachevsky, now deputy commissar for Defence, envisioned mechanized warfare as the wave of the future and tried to lead the Red Army away from its reliance on traditional cavalry units. Zhukov was exposed to both deep battle theory and mechanization at the Frunze. However, it is important to note that deep battle was not accepted as official doctrine until 1933. Furthermore, the emphasis on mechanization issues tends

Zhukov as commander of the 39th Cavalry Regiment, 1923. (Author)

Zhukov as commander of the 39th Cavalry Regiment, c.1929. Zhukov commanded this regiment for seven years between 1923 and 1930 and developed a reputation for meticulous attention to detail. (Author)

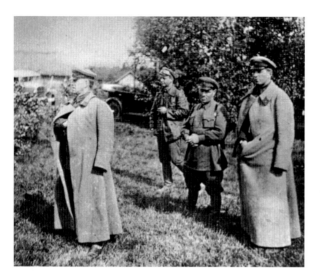

to overlook the role of cavalry within the Red Army, which was actually growing during the inter-war period.

After a year at the Frunze, in May 1930 Zhukov returned to the 7th Cavalry Division as commander of its 2nd Cavalry Brigade, which included his old regiment. He was then detached in February 1931 to become assistant to General Semyon Budyonny, who was then inspector of Red Army cavalry. As the former commander of the Konarmia and a close confidant of Stalin, Budyonny was virtually the 'patron saint' of Red cavalry and Zhukov's association with him had a huge impact on the young officer's career.

Komdiv Zhukov watching his 4th Cavalry Division during the 1934 summer manoeuvres in the Byelorussian Military District. Zhukov's division was consistently ranked as one of the best cavalry divisions in the Red Army, which helped to sharpen his growing reputation. (Author)

After two years with Budyonny, Zhukov was given command of the 4th Cavalry Division in the Byelorussian MD in March 1933. Zhukov had a very successful four years in division command and was rewarded with the Order of Lenin for his superior performance. During this period, his division was given a battalion of light tanks, which gave Zhukov some exposure to mechanized operations in summer manoeuvres. However, Zhukov was on the periphery of Soviet mechanization efforts during the 1930s, not in the mainstream as he later claimed.

Modernization of the Red Army from a primarily infantry-cavalry force to one based on large mechanized formations and specialist units such as paratroopers proceeded at a rapid pace in the mid-1930s, forcing the Soviet officer corps to become increasingly professionalized. However, this trend toward greater specialization reduced the role of political officers (who were largely ignorant of technical issues) and thereby threatened to undermine

Zhukov with his wife Aleksandra and daughters Era and Ella in early 1939. Zhukov was never much of a family man, having an illegitimate daughter with a mistress prior to the war and then going through several 'field wives' during the war. He unceremoniously dumped his wife after the war. (Author)

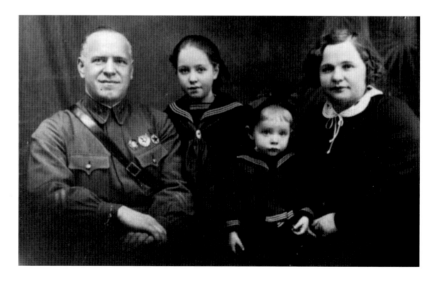

the Communist Party's control over the military. Egged on by Lavrenti Beria's NKVD secret police Stalin became increasingly suspicious that military modernization was a threat to his personal dictatorship. In May 1937, Stalin ordered the NKVD to arrest and torture Tukhachevsky, Uborevich and other senior commanders, beginning a major purge of the Red Army. Budyonny was one of the judges at the secret trial and he accused Tukhachevsky of 'wrecking' by trying to form the Red Army's first tank divisions. After a drumhead trial, most of these condemned officers were executed in June 1937. When Zhukov's corps commander was also arrested, he was moved up to take command of the III Cavalry Corps in Minsk. Zhukov later suggested that he was himself on the verge of arrest, but his connections to Budyonny probably helped save his life and career. During this savage period of the purges, 60 of the 67 Red Army corps commanders were arrested and 57 were executed; Zhukov was one of the survivors. It is also possible that he survived because he was viewed as a military reactionary and more politically reliable than the group of military modernizers, who were ruthlessly purged. Zhukov remained as corps commander in 1937–38 and then became deputy commander of cavalry in the Byelorussian MD in 1938–39. Up to this point, he had demonstrated skills as a disciplinarian and a survivor, but not as a competent battlefield commander. However, this was about to change as trouble developed with Japan in the Far East.

Marshal Semyon Budyonny, who was the grand patriarch of the Red Army's cavalry and a close associate of Stalin. Zhukov's connection with Budyonny was an important factor in his surviving the purges of 1937–41. (Author)

THE HOUR OF DESTINY, 1939–45

Khalkhin-Gol, 1939

In August 1938, the Japanese Kwangtung Army aggressively pushed across the border near Vladivostok and inflicted a tactical defeat upon three Soviet rifle divisions at the battle of Lake Khasan. Concerned that this local success would lead to further Japanese aggression, Stalin grew alarmed when Soviet intelligence warned that the Kwangtung Army was sending forces to the Mongolian border in the spring of 1939. The Japanese deliberately chose a remote area of the border that would be difficult for the Soviets to defend since it was 435 miles (700km) from the nearest railhead. Mongolia was a Soviet-controlled puppet state and this area fell within the responsibility of Komandarm Ivan S. Konev's Trans-Baikal MD, which was subordinate to Komandarm Grigori Shtern's Far Eastern Front.

When the Kwangtung Army massed the reinforced 23rd Infantry Division and two tank regiments near the Khalkhin-Gol River in May 1939, Shtern assembled a composite group known as the 57th Special Corps to oppose them. After some initial skirmishing, it became evident that the Japanese

Victory at Khalkhin-Gol, 20–31 August 1939

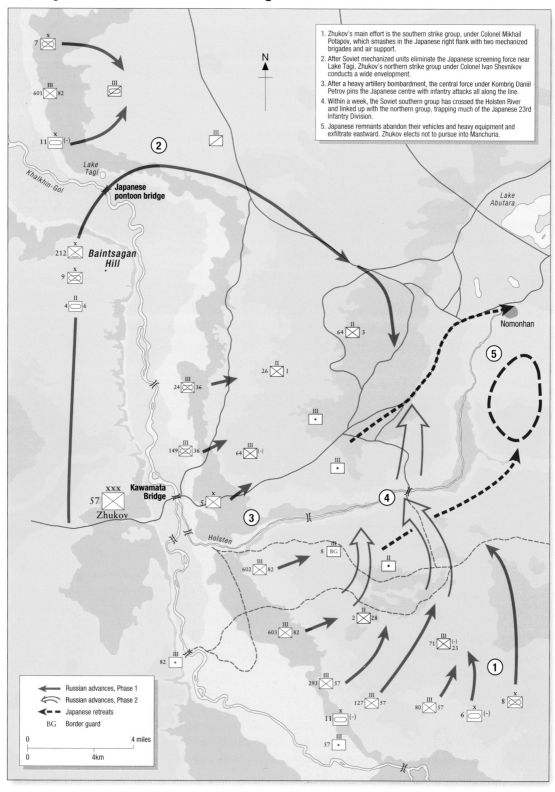

N

1. Zhukov's main effort is the southern strike group, under Colonel Mikhail Potapov, which smashes in the Japanese right flank with two mechanized brigades and air support.
2. After Soviet mechanized units eliminate the Japanese screening force near Lake Tagi, Zhukov's northern strike group under Colonel Ivan Shevnikov conducts a wide envelopment.
3. After a heavy artillery bombardment, the central force under Kombrig Daniil Petrov pins the Japanese centre with infantry attacks all along the line.
4. Within a week, the Soviet southern group has crossed the Holsten River and linked up with the northern group, trapping much of the Japanese 23rd Infantry Division.
5. Japanese remnants abandon their vehicles and heavy equipment and exfiltrate eastward. Zhukov elects not to pursue into Manchuria.

Lake Tagi

Khalkhin-Gol

Lake Abutara

Japanese pontoon bridge

Baintsagan Hill

Nomonhan

Kawamata Bridge

Zhukov

Holsten

	Russian advances, Phase 1
	Russian advances, Phase 2
	Japanese retreats
BG	Border guard

0 4 miles

0 4km

12

were preparing a major cross-border attack. Stalin realized that he needed a steady commander in this theatre and a cavalry officer appeared best suited to the open plains warfare in Mongolia. On 1 June, Komdiv Zhukov received a call from Marshal Kliment Voroshilov ordering him to fly to Mongolia to assess the situation. A few days later, Zhukov reported to Shtern's headquarters in Chita and after informing Moscow about the lack of proper defensive preparations, Voroshilov authorized Zhukov to take command of the 57th Special Corps. Within this command, Zhukov had

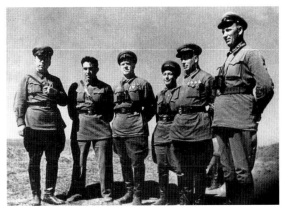

about 50,000 troops from the 36th Motorized Rifle Division, the 11th Tank Brigade, three armoured car brigades and a cavalry brigade – an impressive strike force by 1939 standards.

Zhukov's opponent at Khalkhin-Gol was Lieutenant-General Komatsubara Michitaro, who decided to conduct a bold dual-pincer attack in July to encircle and crush Zhukov's forces before they were fully deployed. Prior to the ground offensive, the Japanese launched an air strike that knocked out most of the Soviet aircraft in the region, thereby ensuring temporary air superiority. Komatsubara then committed a reinforced infantry regiment and all his armour against Zhukov's forces on the east bank of the river. Once Zhukov was focused on this frontal attack, Komatsubara quietly sent the Kobayashi detachment – seven infantry battalions – to a remote and lightly guarded sector of the Khalkhin-Gol front on the evening of 2 July. Japanese engineers succeeded in building a pontoon bridge across the river during the night. Kobayashi achieved complete surprise in crossing the river and captured the important Baintsagan Hill on the morning of 3 July.

There is little doubt that Zhukov was caught off guard; he had relied too heavily upon the Mongolians to cover his left flank and neglected to

The Soviet command team in Mongolia, 15 June 1939. Left to right: Front Commissar Nikolai I. Biryukov, Aviation Commander Yakov V. Smushkevich (executed 1941), Corps Commander Georgy Zhukov, Corps Commissar Mikhail S. Nikishev (KIA 1941), Front Commander Grigorii M. Shtern (executed 1941) and artillery commander Nikolai N. Voronov. (RIA Novosti, 58536)

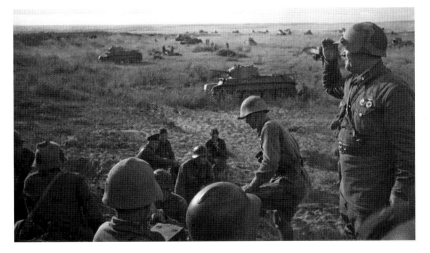

The Soviet 6th Tank Brigade prepares for Zhukov's counteroffensive in an assembly area. Although he had minimal experience handling large armoured formations, Zhukov was able to synchronize an impressive combined-arms offensive on 20 August 1939. (RIA Novosti, 61242)

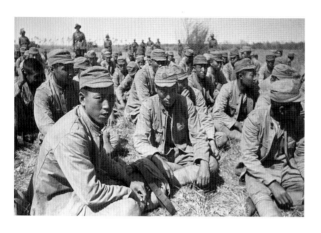

Over 3,000 Japanese soldiers were taken prisoner during Zhukov's offensive. The humiliating defeat of the 23rd Infantry Division ensured that Japan would not seek further conflict with the Red Army. (RIA Novosti, 40947)

put any troops on Baintsagan Hill. However, if the measure of a commander is the ability to react to unexpected crisis, Zhukov demonstrated real mettle in responding to this Japanese coup. While using his artillery to contain the Japanese attack east of the Khalkhin-Gol, Zhukov immediately committed Kombrig Mikhail P. Yakovlev's 11th Tank Brigade to counterattack Kobayashi's infantry, which had no armour support. He also directed Colonel Ivan I. Fediuninsky's 24th Motorized Infantry Regiment to hit the flank of Kobayashi's force and he fed the 7th Armoured Car Brigade into the battle later in the day. Although the unskilled Soviet tankers reduced the power of Zhukov's counterattack by attacking in small platoon- and company-sized groups, thereby enabling the Japanese to mount desperate close-quarter attacks with Molotov cocktails, Kobayashi's infantry was hard pressed and suffered about 800 casualties. Yakovlev's 11th Tank Brigade lost 77 of its 133 BT-5/7 tanks, but Kobayashi's force expended nearly all its ammunition. Impetuously, Komatsubara crossed the pontoon bridge with his staff and was nearly killed by Soviet tanks. Rattled by this incident and unsettled by Zhukov's powerful counterattack, Komatsubara decided to evacuate the bridgehead and redeploy his entire division to crush Zhukov's forces on the east bank. Meanwhile on the east bank, Zhukov's defences knocked out half the Japanese armour and stopped the attackers a mile short of the Kawamata Bridge. A second major Japanese offensive launched on 23–25 July failed to achieve a breakthrough on the east bank and devolved into a costly attritional slugfest over a few hilltops. By late July, the Japanese were running short of artillery ammunition and forced to shift to the defence. During the July fighting, Zhukov displayed a stolid command style and refused to be knocked off balance by unexpected Japanese advances but he also began displaying a predilection for brutality and threats that would become his trademark method for instilling 'fighting spirit'.

After the heavy fighting in July, both sides lapsed into a period of static, small-scale warfare while they replenished their depleted formations. Stalin authorized a counteroffensive as soon as feasible and Konev and Shtern gathered over 4,000 trucks to sustain Zhukov's forces along the Khalkhin-Gol and sent him several more divisions and two tank brigades. Stalin also committed a reinforced aviation group that enabled the Soviet Air Force (VVS) to gain air superiority over the battlefield. The Soviet logistic effort in Mongolia enabled Zhukov to gain the initiative. Once reinforced and re-supplied, Zhukov quietly began redeploying his armour and mechanized forces to the flanks, while conducting a brilliant *maskirovka* (deception) effort that fooled Komatsubara into believing that the Soviet effort would be made in the centre. Attacking in force on the morning of 20 August, Zhukov

pounded Komatsubara's forces with a massive artillery barrage and 100 bombers. In five days of heavy fighting, Zhukov's troops encircled most of the 23rd Infantry Division around Nomonhan. Zhukov then used his artillery and air power to pulverize the trapped Japanese division, although thousands of troops escaped the pocket without their equipment. All told, the Japanese suffered at least 20,000 casualties against 23,000 Soviet casualties. After this defeat, the Japanese recognized that their army was not prepared to compete with the Red Army and decided to sign a non-aggression treaty with

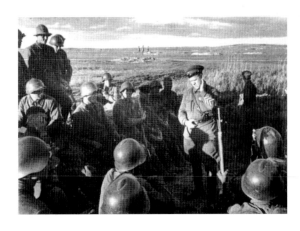

Stalin. For Zhukov, his victory at Khalkhin-Gol earned him the Hero of the Soviet Union award and marked him as a rising star. However, Zhukov was quick to hog the limelight and downplay the role of others in the victory.

Zhukov delivering a pre-battle lecture to his troops at Khalkin-Gol in the summer of 1939. Zhukov rarely interacted with the troops under his command and adopted a bullying style of leadership. (Author)

The rising star, 1940–41

Zhukov was brought back west and made deputy commander of the Ukrainian MD and then in early 1940 he was given command of the important Kiev MD. Owing to these assignments, Zhukov did not participate in the disastrous Russo-Finnish War of 1939–40, which was probably fortunate for his career. In June 1940 Zhukov led the lesser-known invasion of the Romanian province of Bessarabia, which was his first command of a front-sized formation as well as his first involvement in Stalinist aggression and crimes.

Although Stalin was hopeful of avoiding conflict with Germany in the immediate future, he instructed Timoshenko to enact measures to increase the Red Army's overall defence preparedness. Accordingly, Timoshenko held a seminar of senior Soviet military leaders, including Zhukov, in Moscow in December 1940 to discuss defensive preparations against Germany.

A staged propaganda photo purporting to show Bessarabian citizens welcoming Zhukov's Red Army troops on 28 June 1940. (RIA Novosti, 103027)

Based upon these discussions, a war game was scheduled for 8–11 January 1941, with Zhukov directing the German team versus the Soviet team led by General Dmitri Pavlov. Zhukov put on a virtuoso performance at the January war game, and his simulated invading forces advanced deeply into Byelorussia and routed much of Pavlov's command. When called upon to report the results of the war game to Stalin, Army Chief of Staff General Kirill Meretskov was hesitant to explain how the German team could have prevailed, since pointing out the Red Army's deficiencies could land him in the NKVD's Lubyanka prison. Angered by Meretskov's reluctance, Stalin made the snap decision to relieve him and appoint the more aggressive Zhukov as chief of staff on 15 January.

Zhukov was suddenly catapulted into one of the top spots in the Red Army, but he had no General Staff training and

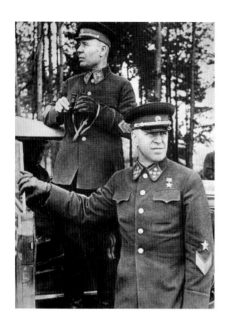

Zhukov was given command of the Kiev MD after his victory at Khalkin-Gol and he worked closely with Marshal Timoshenko to prepare for the German invasion. (RIA Novosti, 7381)

very limited staff experience. Zhukov was a hands-on cavalry officer, not inclined to paperwork and his performance in the war game was in part due to talented subordinates such as Vatutin. Stalin now tasked Zhukov to work with Timoshenko to prepare the Red Army for eventual confrontation with the German Wehrmacht, although hopefully not before the ongoing modernization programmes reached fruition. Yet time was running out and only five months remained before Germany intended to invade the Soviet Union. During this period, Zhukov's main contribution was to convince Timoshenko, then Stalin, that reserve troops should be mobilized to bring the understrength frontier armies up to full strength. Zhukov visited the border regions in April 1941 and found many defensive positions incomplete, but his recommendations to remedy these deficiencies fell on deaf ears. As intelligence reports about the German build-up in Eastern Europe continued to pour in, Zhukov advocated more aggressive measures and on 15 May he submitted a proposal for a Soviet pre-emptive attack on German assembly areas in Poland. Stalin rejected it and repeated his belief that hostilities were not imminent. Timoshenko called an emergency meeting at the Kremlin on the evening of 21 June and he and Zhukov began sending telegrams to warn all commands, but these were not received until just two to three hours before the Germans began crossing the border. When Zhukov tried to relay reports about the initial German air raids to Stalin he dismissed them as mere provocations and refused to accept that the invasion had begun.

Zhukov orchestrates the Red Army's first effective combined-arms attack, 0900hrs, 20 August 1939

After more than a month of semi-static warfare against the Japanese 23rd Infantry Division along the Khalkhin-Gol River in the summer of 1939, Zhukov quietly assembled overwhelming mechanized forces on both enemy flanks in order to mount a devastating double envelopment attack. For the first time, Zhukov employed his trademark *maskirova* effort and a well-planned logistic build-up to position himself for a decisive blow on the morning of 20 August. At 0900hrs, the Southern Task Force, commanded by Colonel Mikhail I. Potapov, led parts of three mechanized brigades and an infantry regiment against the flank of the Japanese 71st Infantry Regiment. Zhukov masterfully coordinated a heavy artillery preparation with a massive airstrike to neutralize the Japanese artillery and suppress the enemy defences long enough for his ground troops to close and eliminate the disorganized resistance nests. This attack was the first synchronized combined-arms offensive ever mounted by the Red Army and its efficient execution stood in stark contrast to the debacle in Finland a few months later, which helped to secure Zhukov's reputation as a competent tactician. However, Zhukov would not be able to repeat this performance again for another five years.

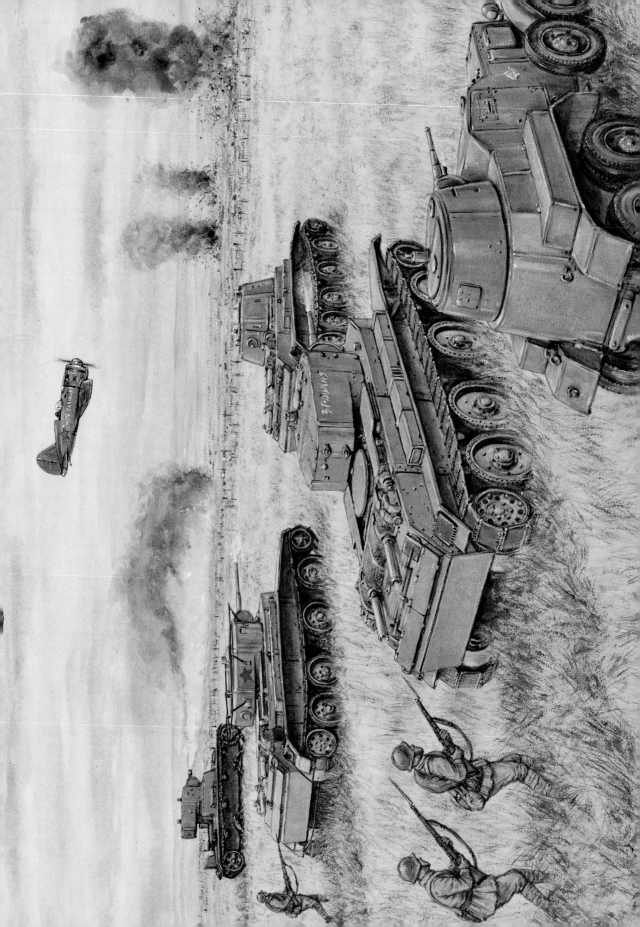

Border battles, 1941

While Stalin retreated into a temporary funk, others took charge. On the second day of the war, the Stavka (headquarters) of the Supreme High Command (SVGK) was activated and its senior members were Stalin, Foreign Minister Molotov, Zhukov, Timoshenko, Marshal Kliment Voroshilov, Budyonny and Admiral Nikolai G. Kuznetsov. The Red Army General Staff (GSHKA) worked for the Stavka in preparing operational plans. However, rather than a true headquarters that functioned on military logic, the Stavka was controlled by the State Defence Committee (GKO), composed of Stalin, NKVD chief Lavrenti Beria, Voroshilov, Molotov and Politburo insider Georgy Malenkov. Zhukov was questioned frequently about his operational planning by politicians with a limited grasp of military affairs. Beria proved to be a constant thorn in the side of Soviet field commanders and the Stavka, ready to depict any failure as evidence of conspiracy.

Since communications with the frontier armies was extremely poor and Stalin mistrusted many of his army commanders, the GKO decided to send trusted members of the Stavka to critical areas to ensure that their operational orders were faithfully carried out. Zhukov was sent to the Ukraine to supervise General-Colonel Mikhail Kirponos, who had replaced him as commander of the Kiev MD. On paper, Kirponos had the best formations in the Red Army, including six mechanized corps and, according to pre-war planning, he was supposed to mass his armour and conduct an immediate counteroffensive against the invader. Yet when Zhukov arrived at Tarnopol on the evening of 23 June, Kirponos was reluctant to begin a counteroffensive because his mechanized corps were still en route to the border. Logistical difficulties, including fuel and ammunition shortages, greatly degraded the effectiveness of Kirponos' forces and he wanted to remain on the defensive until he could sort these issues out. Zhukov brusquely rejected these excuses and ordered Kirponos to counterattack the German Panzer spearhead without delay. Unable to mass all his forces so quickly, Kirponos attacked Kleist's Panzergruppe 1 with the units available, resulting in the battle of Dubno, the first major tank battle on the Eastern Front. Although some German units were stressed by the counterattacks, the end result was that Kirponos' six mechanized corps were committed piecemeal and destroyed by the experienced German Panzer units. After spending three days with Kirponos, Zhukov returned to Moscow, but continued to send him telegrams exhorting him to continue attacking.

Kirponos' counterattacks succeeded in delaying the German drive on Kiev, but much of the South-western Front's capabilities were chewed up in the process. After a month of heavy combat, Zhukov realized that Kiev was a higher priority for the Germans than Moscow and urged Stalin

Zhukov observing defensive manoeuvres in the Kiev MD on 1 November 1940. In order to improve the realism of training, he created a regiment-sized 'opposing force' unit to provide a credible adversary in tactical training. He also managed to get six of the nine new mechanized corps transferred to his district. (RIA Novosti, 25458)

to authorize withdrawals to save the South-western Front before German pincers encircled it. Stalin angrily rejected Zhukov's assessment and relieved him on 30 July. Zhukov was sent to command the Reserve Front, composed primarily of militia units and new infantry recruits assembling near Vyazma as a backstop for the hard-pressed Western Front.

Unable to influence further the developing catastrophe around Kiev, Zhukov refocused on the situation on the approaches to Moscow. Having sent much of its armour south to envelop Kirponos' command, the German Heeresgruppe Mitte had temporarily shifted to the defence around Smolensk and AOK 4's bridgehead over the Dnepr at Yelnya was vulnerable to counterattack. Stalin and the GKO ordered the Western and Reserve fronts to launch a major counteroffensive against the Yelnya Salient during this window of opportunity and Zhukov was allowed to coordinate the operation. Zhukov massed ten divisions of the 24th Army against the six German divisions in the salient and spent three weeks pounding the enemy with relentless infantry and artillery attacks. As casualties mounted, Kluge's AOK 4 abandoned the Yelnya Salient on 8 September – the first major German retreat of World War II. Success at Yelnya helped to restore Zhukov's credibility in Stalin's eyes and he was recalled to Moscow. However, the price of this tactical victory was over 30,000 casualties in the 24th Army – a fact that did not concern Zhukov.

The situation in northern Russia was also poor, with German forces approaching Leningrad. The Stavka had sent Voroshilov and Vatutin to direct the defence of the city, but they failed to stop Leeb's forces from crossing the Luga River. Stalin relieved Voroshilov when he found that he was lying about the German advance that severed the last rail link into the city. The GKO directed Zhukov to fly into Leningrad, take charge of the defence and hold the city at all costs. Yet by the time that Zhukov arrived in Leningrad on 13 September, the city was already surrounded and the isolated Soviet armies were on the verge of collapse. Zhukov put his protégé from Khalkhin-Gol, General-Major Ivan I. Fediuninsky in charge of the faltering 42nd Army and ordered immediate counterattacks against the German spearheads on the Pulkovo Heights, overlooking the city. Using a battalion of KV heavy tanks and some of the better militia units, the Soviet defenders were able to slow Leeb's advance. Zhukov also ambitiously ordered the badly depleted 8th Army to attack the west side of the German advance and retake Krasnoye Selo while the partly formed 54th Army and Neva Operational Group were ordered to retake Mga and break the blockade of Leningrad.

Heeresgruppe Nord had little difficulty containing Zhukov's premature counteroffensive and struck back, isolating the 8th Army in the Oranienbaum Bridgehead and maintaining a firm hold on Mga. When Zhukov's counteroffensive failed to raise the blockade of Leningrad, he lashed out in fury and on 17 September informed all commanders that anyone who retreated – and their families – would be shot. Over the next several days, the German advance ground to a halt just south of the city in heavy fighting around Pushkin. Hitler ordered Heeresgruppe Nord to

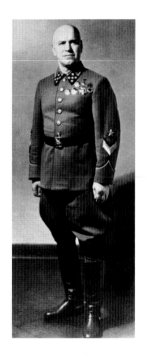

Zhukov in early 1941, just after being appointed as chief of the General Staff. Stalin's purge of the Red Army in 1937–41 facilitated Zhukov's rapid rise and allowed him to ascend from division commander to one of the most senior officers in the Red Army in less than four years. (Author)

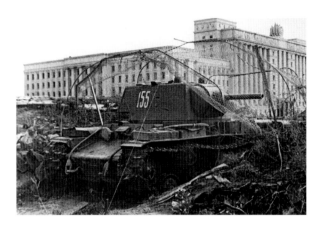

A KV-1 heavy tank in a defensive position in Leningrad, 1 October 1941. Zhukov massed the available heavy armour and used it to counterattack the advancing German forces on the Pulkovo Heights. (RIA Novosti, 601304)

A column of BT-7 tanks rolls through Moscow on its way to the front, 1 November 1941. Zhukov was forced to fight the battle of Moscow without the usual Soviet numerical superiority and the bare minimum of armour and artillery support. (RIA Novosti, 43022)

transfer most of its Panzer units to Heeresgruppe Mitte for Operation *Typhoon*, the final advance on Moscow, and ordered Leeb to shift to the defensive and starve Leningrad into submission.

Was Zhukov responsible for the 'Miracle on the Neva' that saved Leningrad? There is little doubt that his brutal methods put some steel into the Soviet defence that helped to bring the final German attacks to a grinding halt in bloody attritional battles. However, Zhukov's deference to Stalin's demand for a premature counteroffensive resulted in thousands of needless casualties that seriously weakened the Soviet armies in and around Leningrad and, ultimately, prevented the relief of the city during the Winter Counteroffensive of 1941–42.

The defence of Moscow, 1941

As the German threat to Leningrad receded, the threat to Moscow worsened in early October as Heeresgruppe Mitte began Operation *Typhoon*. In short order, Konev's Western and Budyonny's Reserve Fronts were encircled and annihilated in double envelopments around the cities of Vyazma–Bryansk, leaving the approaches to Moscow virtually unguarded. In the south, Kiev had fallen and Kirponos had been killed in action along with the bulk of the South-western Front, just as Zhukov had warned. In this hour of desperation, with the Red Army on the ropes on virtually every front, Stalin recalled Zhukov to Moscow on 6 October. Arriving at the Kremlin on the 7th, Zhukov was shocked to find an air of panic in the top leadership, with even Stalin muttering about the possibility of requesting an armistice with the Germans before all was lost. Marshal Boris Shaposhnikov, an old General Staff officer who had taken over as Army Chief of Staff after Zhukov's dismissal, ordered Zhukov to proceed to the Western Front to assess the situation.

Zhukov reached the Western Front headquarters near Mozhaisk on 8 October and discovered that there were almost no units defending the approaches to Moscow since the best units were trapped in the Vyazma–Bryansk encirclements and the remnants were dispersed and leaderless. Budyonny was totally out of his depth as a front commander and had no clue on how to stop the blitzkrieg. Supply difficulties and muddy roads were beginning to slow down the German advance, but Bock's Heeresgruppe Mitte was now within 125 miles (200km) of Moscow. Konev's defeated Western Front had virtually no armour or heavy artillery

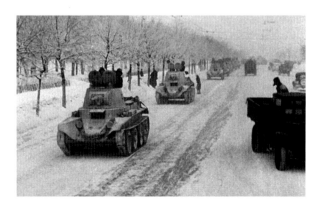

left, just hastily trained infantrymen. Furthermore, Stalin was disgusted with Konev's inability to stop Bock and wanted him executed. In Moscow, Shaposhnikov was working miracles to gather reinforcements from across the Soviet Union, but this would take weeks and in the meantime someone would have to hold the approaches to Moscow.

Stalin made Zhukov the new commander of the Western Front and, based upon his recommendation, decided to defer shooting Konev. However, Stalin informed Zhukov that if Moscow fell, both generals would pay with their lives. Motivated by the threat of death, Zhukov now put on one of the best performances of his military career. He began by issuing a draconian order to execute all deserters, which NKVD blocking detachments were quick to implement. Unable immediately to construct a new front line, Zhukov ruthlessly massed his few available units at the key towns of Mozhaisk, Volokolamsk and Naro-Fominsk, while leaving

Zhukov at the Western Front headquarters at Odintsovo on 20 November 1941. By this point, the German offensive toward Moscow was in its final throes and Zhukov was preparing a major counteroffensive with the last of the Stavka reserves. Early in the battle, Stalin told Zhukov that if Moscow fell, he, Konev and Rokossovsky would pay with their lives. (RIA Novosti, 1596)

other areas undefended. Bock's spearheads were thus able to continue advancing into undefended parts of the front and captured Rzhev and Kalinin but when they ran into Zhukov's carefully placed roadblocks, they were forced to conduct set-piece attacks. Zhukov also sacrificed several of the new tank brigades to conduct delaying actions on the Minsk–Moscow highway, which expended much of his remaining armour but cost the Germans more time. By the time that the Germans encountered the Mozhaisk Line, Zhukov had managed to gather 90,000 troops to hold the 30-mile (50km) front. Ultimately, Heeresgruppe Mitte smashed its way through Zhukov's thin line by late October but then had to pause 55 miles (90km) from Moscow for resupply.

While Bock regrouped his forces for a final lunge toward Moscow, Zhukov and Shaposhnikov worked tirelessly to build a new front in front of the capital. Although some of the reinforcements did come from Siberia, the 82nd Motorized Rifle Division was the only one of Zhukov's Khalkhin-Gol veterans that arrived to participate in the battle of Moscow. Zhukov tried to gather a small reserve but Stalin kept the better units under Stavka control and only grudgingly doled out tanks and artillery to the front line. Nevertheless, Zhukov and Shaposhnikov miraculously built a new Western Front before the Germans were able to resume *Typhoon* in mid-November. Konev was put in charge of the new Kalinin Front. On 15 November, the Germans began the second phase of Typhoon with 3. and 4. Panzerarmeen attacking Rokossovsky's 16th Army on the north-west approaches to Moscow. Rokossovsky argued with Zhukov to adopt a more elastic defence but Stalin had decreed no more retreats and Zhukov ordered his former superior to die in place, if necessary. Rokossovsky's 16th Army bent but did not break and the German offensive finally culminated 12 miles (19km) from the Kremlin, just as freezing winter weather arrived. Zhukov also orchestrated a well-timed counterattack that repulsed Kluge's tardy offensive

by AOK 4 at Naro-Fominsk. Finally facing reality, Hitler ordered Heeresgruppe Mitte to shift to the defensive.

Shaposhnikov had been planning a major counteroffensive since late November and had gathered three new armies for the operation, but they were critically short of tanks and artillery. As soon as *Typhoon* ended, Stalin ordered Zhukov to counterattack. Although they preferred to wait for more reinforcements, Zhukov and Konev began the Moscow counteroffensive on 5 December as a series of tentative jabs and probes that revealed the weakness of Heeresgruppe Mitte's front-line units. Zhukov's forces quickly enveloped the two German Panzer armies in the Klin Bulge and Guderian's 2. Panzerarmee outside Tula. Despite the limited offensive capability of his poorly trained troops, Zhukov's shock groups managed briefly to surround the bulk of 3. Panzerarmee at Klin. The trapped Germans managed to escape the Soviet pocket but were forced to abandon much of their artillery and vehicles and fall back in disorder from Moscow. By 15 December, Konev's troops had liberated Kalinin and Zhukov's Western Front had inflicted a serious defeat on Heeresgruppe Mitte. Unlike his later campaigns, Zhukov was forced to fight at Moscow without the usual Soviet numerical superiority in troops, tanks and artillery, or the logistical stockpiles to support sustained combat operations. Additionally, most of his troops had little training and morale was so close to cracking in October that even the NKVD and political commissars were losing their grip on the Red Army. During this crisis, Zhukov's determination and tenacity were instrumental in holding the Western Front together and preventing a complete collapse. While it is debatable whether or not Zhukov saved Leningrad, he clearly played the pivotal role in saving Moscow.

German vehicles abandoned during the retreat from the Klin Bulge. Zhukov was able to force all three over-extended German Panzer armies into headlong retreat from Moscow and nearly destroyed 3. Panzerarmee. (Courtesy of the Central Museum of the Armed Forces Moscow via Nik Cornish)

Winter Counteroffensive, 1942

Satisfied that Heeresgruppe Mitte was repulsed and the immediate threat to Moscow was gone, Zhukov preferred to pause until sufficient reinforcements and supplies were gathered to mount a decisive push. The Western Front suffered over 260,000 casualties during the first phase of the Winter Counteroffensive and most of Zhukov's combat units were down to 20 per cent strength. He also preferred that other Soviet fronts remained on the defensive, so that Stavka reserves could be concentrated along just the Moscow–Smolensk axis, thereby boosting the probability of a major victory. However, Stalin believed that the success of the initial attacks in early December indicated that the Germans were close to complete collapse and he wanted to strike them again while they were still off-balance and across a much wider front. Consequently, the GKO directed Zhukov and Konev, as well as the newly formed

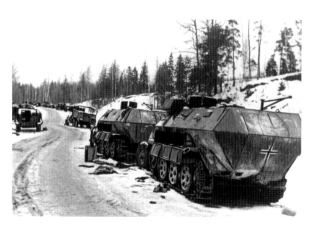

Bryansk Front, to begin the second phase of the counteroffensive against Heeresgruppe Mitte on 7 January 1942. The Western Front was reinforced to nine armies with 66 divisions and over 700,000 troops, giving Zhukov operational control over one-fifth of the Red Army's strength. Yet in order to satisfy Stalin's demands, the Stavka spread its reserves across multiple fronts, including Leningrad, the Ukraine and the Crimea.

Stalin was correct that Heeresgruppe Mitte's situation was desperate. Konev's Kalinin Front penetrated AOK 9's front near Rzhev, while Zhukov's Western Front created a large gap between 4. Panzerarmee and AOK 4 near Borovsk and another gap between AOK 4 and 2. Panzerarmee near Sukhinichi. Zhukov was given authority to coordinate his operations with Konev's and he decided to make his main effort along the Mozhaisk axis and link up with Konev's forces at Vyazma, thereby encircling at least three German armies and tearing the heart out of Heeresgruppe Mitte. He also decided to make a secondary effort against the 2. Panzerarmee in the Sukhinichi area. This was a grand plan, worthy of Tukhachevsky's vision of deep battle, but well beyond what the threadbare Red Army of January 1942 was capable of accomplishing.

Konev's forces enjoyed considerable success against AOK 9, tearing a hole in the weakly guarded seam between Heeresgruppe Mitte and Heeresgruppe Nord and pushing the 11th Cavalry Corps into the void, but Zhukov was forced to conduct a series of frontal assaults against 4. Panzerarmee and AOK 4 units that were in better shape. Zhukov began his push toward Vyazma by directing the 43rd Army to envelop the German XLIII Armeekorps (AK), which forced much of AOK 4's centre to pull back into a hedgehog around Yukhnov. While the envelopment failed to trap any German forces, the XX AK was now left very exposed and Zhukov moved quickly to exploit this opportunity. He received the 201st Airborne Brigade from the Stavka reserves and ordered it to drop around Znamenka to disrupt communications in the rear of AOK 4. Then, on 19 January 1942, he ordered General-Lieutenant Mikhail G. Efremov's 33rd Army to push past the overextended XX AK, link-up with the paratroopers and advance on to Vyazma, while the 5th Army mounted a major attack on Mozhaisk.

Zhukov formed mixed 'shock groups' of light armour battalions and ski troops to spearhead his offensive against Vyazma in February 1942. Although mobile, these fragile formations lacked the mass or firepower to reduce German hedgehogs. (RIA Novosti, 61127)

The attack on Mozhaisk succeeded and further drove a wedge between AOK 4 and 4. Panzerarmee. Although the initial airborne operation was not very successful, Zhukov decided to increase the pressure on Heeresgruppe Mitte by committing General-Lieutenant Pavel Belov's 1st Guards Cavalry Corps west of Yukhnov to conduct a deep raid behind German lines. Fascinated by the potential of airborne troops and lacking other high-quality reserves, Zhukov ordered the 8th Airborne Brigade to drop west of Vyazma on 27 January to further

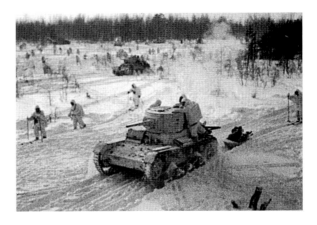

Zhukov's campaigns in the East, 1941–45

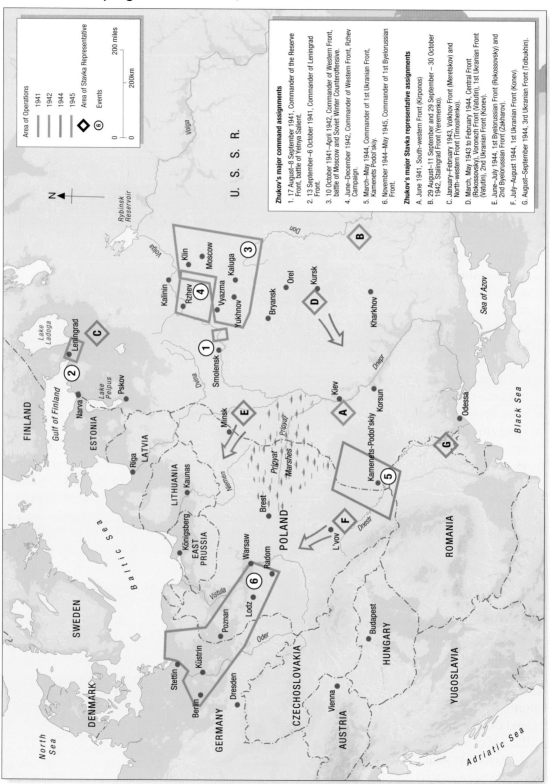

Area of Operations
1941
1942
1944
1945
Area of Stavka Representative

◇ Events ⑥

0 ____ 200 miles
0 ____ 200km

Zhukov's major command assignments

1. 17 August–8 September 1941, Commander of the Reserve Front, battle of Yelnya Salient.
2. 13 September–6 October 1941, Commander of Leningrad Front.
3. 10 October 1941–April 1942, Commander of Western Front, battle of Moscow and Soviet Winter Counteroffensive.
4. June–December 1942, Commander of Western Front, Rzhev Campaign.
5. March–May 1944, Commander of 1st Ukrainian Front, Kamenets Podol'skiy.
6. November 1944–May 1945, Commander of 1st Byelorussian Front.

Zhukov's major Stavka representative assignments

A. June 1941, South-western Front (Kirponos)
B. 29 August–11 September and 29 September – 30 October 1942, Stalingrad Front (Yeremenko).
C. January–February 1943, Volkhov Front (Meretskov) and North-western Front (Timoshenko).
D. March, May 1943 to February 1944, Central Front (Rokossovsky), Voronezh Front (Vatutin), 1st Ukrainian Front (Vatutin), 2nd Ukrainian Front (Konev).
E. June–July 1944, 1st Byelorussian Front (Rokossovsky) and 2nd Byelorussian Front (Zakharov).
F. July–August 1944, 1st Ukrainian Front (Konev).
G. August–September 1944, 3rd Ukrainian Front (Tolbukhin).

24

complicate further the German situation. By 28 January, the Kalinin Front's 11th Cavalry Corps had reached the Moscow–Warsaw highway west of Vyazma and Efremov's 33rd Army was approaching the city from the east. Zhukov appeared to be on the precipice of a momentous victory, leading to the destruction of Heeresgruppe Mitte.

However, Zhukov's window of opportunity was rapidly closing. By the end of January, the German Army was beginning to recover some of its balance after the retreat from Moscow and Hitler replaced the older, defeated commanders with a new generation of battlefield leaders who understood how to counter the Red Army's tactics. General der Infanterie Gotthard Heinrici took over AOK 4 just as Zhukov's offensive against Vyazma was beginning and he quickly demonstrated a mastery of defensive tactics. Despite being badly outnumbered, Heinrici fought Efremov's spearheads to a standstill in late January while 4. Panzerarmee provided improvised *Kampfgruppen* to mop up most of the scattered paratroopers. To the west, Walter Model took over AOK 9 and was beginning to turn the tables on Konev's forces as well.

Impatient for success, Stalin regarded the Western Front as bogged down in a stalemate and he began to strip units from Zhukov's command to send to other fronts. The 1st Shock Army and the 16th Army were transferred, bringing Zhukov's offensive to a temporary halt. Given a respite, AOK 4 and 4. Panzerarmee were able to mount a counterattack on 1 February which encircled most of the 33rd Army and the 11th Cavalry Corps. After pleading with the GKO, Zhukov received 60,000 replacements but instead of making a major effort to relieve his trapped 33rd Army, he cold-bloodedly decided to mount a major attack on 15 February to finish off the German hedgehog at Yukhnov. Zhukov ordered two more airborne brigades dropped south of Vyazma to support his advance and the Germans were forced to abandon Yukhnov by 5 March. However, the Soviet 50th Army was unable to link up with the paratroopers, who were methodically destroyed. It was not until 14 April, with the beginning of spring, that Zhukov made a serious effort to rescue the trapped 33rd Army. The 50th Army launched a desperate attack to break through but the Luftwaffe shattered the offensive with well-timed interdiction strikes. Heinrici then crushed the trapped 33rd Army and its commander, Efremov, committed suicide to avoid capture. Of the 14,000 Soviet paratroopers dropped behind German lines, only 4,000 succeeded in returning to Soviet lines. Belov's cavalry corps spent six months raiding behind German lines and also fought its way out, minus half its personnel. At the cost of over 435,000 casualties, Zhukov's Western Front had advanced only 90 miles (150km) since mid-December and failed to achieve either a major breakthrough or to encircle any large German units.

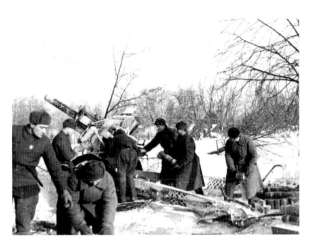

A Soviet M1938 122mm howitzer crew in action during the winter of 1941–42. After the Germans were pushed back from Moscow, Zhukov wanted to wait until he could gather more artillery to support the next phase of the Winter Counteroffensive but Stalin forced him to attack prematurely without the necessary ingredients for a successful combined-arms operation. (Courtesy of the Central Museum of the Armed Forces Moscow via Nik Cornish)

Rzhev, summer 1942

Once the Soviet counteroffensive had run its course, Stalin and the GKO were convinced that the Germans would mount another effort to take Moscow in the summer of 1942. Zhukov remained in command of the Western Front and was provided with thousands of reinforcements to rebuild his decimated divisions. Yet Heeresgruppe Mitte remained on the defensive throughout the summer, while Heeresgruppe Süd began Operation *Blau* on 28 June, which quickly demonstrated that Hitler's strategic focus had shifted southwards. Zhukov now found himself in a backwater theatre while the main action was occurring in the Ukraine and the Crimea. During the summer of 1942, he spent considerable time in Moscow discussing strategic priorities with the GKO and convinced Stalin that putting offensive pressure on Heeresgruppe Mitte would divert German reserves away from their advance toward the Volga. Within four days of the start of Operation *Blau*, the GKO authorized Zhukov to conduct attacks against Heeresgruppe Mitte and the obvious choice was the Rzhev Salient, which had fended off both the Kalinin and Western Fronts throughout the winter, but which remained vulnerable to a joint pincer attack. He also wanted to renew the offensive against 2. Panzerarmee north of Orel. Zhukov convinced Stalin that if he could push in either of Heeresgruppe Mitte's flanks, Hitler would be forced to divert units from Operation *Blau*.

Zhukov began by attacking the 2. Panzerarmee with Rokossovsky's 16th Army, the 61st Army and two tank corps on 5 July. However, this hasty offensive was poorly coordinated and, when the Germans shifted three Panzer divisions to the area, it was repulsed with heavy losses. The effort against Rzhev was better prepared and achieved some success. Konev's Kalinin Front attacked the west side of the Rzhev Salient with two armies on 30 July and five days later Zhukov's Western Front attacked the east side with two more armies. Armeeoberkommando 9, temporarily under the command of Generaloberst Heinrich von Viettinghoff, was forced back 20 miles (32km) and had to evacuate the town of Zubtsov, but neither front achieved a breakthrough. Walter Model returned just as Zhukov's offensive was running out of steam and quickly restored a stable front for AOK 9. Despite the limited nature of the success at Rzhev, Stalin decided to reward Zhukov by appointing him as deputy supreme commander on 26 August and to send him to Stalingrad to advise on the deteriorating situation on that front. Zhukov handed command of the Western Front to Konev and the Kalinin Front was given to General-Colonel Maksim Purkaev, but he intended to return soon. In Moscow, Zhukov convinced the GKO that AOK 9 had been on the verge of collapse but that he lacked the resources to accomplish the mission.

As deputy supreme commander, Zhukov appeared to be at the apogee of his wartime power and influence. However, Stalin was already growing suspicious of Zhukov's growing reputation as a hero and actively sought to undermine him even as he granted him the new title. Stalin regarded all military men as disposable once they served their purpose and Zhukov was no different. In May, Stalin directed Beria's NKVD to begin gathering evidence against Zhukov

and Viktor Abakumov of the sinister Special Department began putting pressure on Zhukov's staff. Zhukov's able chief of staff, General-Major Vladimir S. Golushkevich, was arrested and imprisoned for ten years when he failed to provide damning testimony against his commander. Realizing that he too was at risk, Zhukov did not lift a finger to save his subordinates from the NKVD and later virtually whitewashed them out of his memoirs.

Stalingrad and Stavka planning, August–November 1942

Zhukov flew to the Stalingrad area on 29 August and before even taking time to absorb situation reports, he began demanding an immediate counteroffensive against Paulus' AOK 6 on the approaches to Stalingrad. General-Lieutenant Andrei I. Eremenko and his senior commissar Nikita Khrushchev had their hands full trying just to stop the Germans from advancing into the city but they were obliged to comply with Zhukov's demand. Zhukov directed the 1st Guards Army to strike the narrow corridor north of Stalingrad, where the German XIV Panzerkorps had pushed through to the Volga. The Kotluban' Offensive began on 3 September and made some small advances before quickly grinding to a halt in the face of intense German resistance. Zhukov often displayed a tendency to reinforce failure and he widened the offensive by adding in the 4th Tank Army, 24th and 66th Armies to assist the 1st Guards Army by attacking across a broader front. Unfortunately, Generalleutnant Hans-Valentin Hube's 16. Panzer-Division conducted an inspired defence and Luftflotte IV smothered the Soviet offensive with relentless air strikes. Finally, after nine days of fruitless attacks, Zhukov called off the offensive and told Stalin that he had succeeded in delaying the German advance into the city. There is no doubt that Paulus was severely distracted by nine days of relentless Soviet attacks on his left flank, but Eremenko's Stalingrad Front suffered about 80,000 casualties and lost 300 tanks in Zhukov's hasty attack. Eremenko's main mobile reserve, 4th Tank Army, lost 81 percent of its armour in this ill-judged offensive. Even as Zhukov flew back to Moscow on 12 September, the AOK 6 and 4. Panzerarmee were fighting their way into the northern suburbs of Stalingrad and the crisis had virtually the entire Soviet command cadre in despair.

Back in Moscow, Zhukov met with the GKO and claimed that his offensive had successfully prevented the loss of Stalingrad, even though the battle was still clearly in doubt. Zhukov also delivered three important assessments to the GKO: (1) in order to defeat AOK 6, a future Soviet offensive should seek a wider envelopment against its exposed flanks, (2) the Stalingrad Front should remain on the defensive and fight an attritional battle in the city to force Paulus to commit all his reserves to that effort and (3) he believed the Germans had committed most of their mobile reserves to the Stalingrad operation, which meant that they were vulnerable to Soviet

Ivan Konev (1897–1973) commanded six different fronts and remained in key front-line positions throughout 1941–45. Often subordinate to Zhukov during the fighting around Rzhev and in the Ukraine, Konev resented Zhukov's micromanagement and eventually emerged as a rival during the race for Berlin. (Author)

offensives elsewhere on the Eastern Front. Zhukov ordered Eremenko to conduct another counteroffensive against Paulus' northern flank, but the Second Kotluban' Offensive from 23 September to 2 October resulted in yet another costly failure.

During the period 12–28 September 1942, Zhukov participated in a debate within the Stavka and the GKO about offensive planning for the autumn. General-Colonel Aleksandr M. Vasilevsky, chief of the General Staff after Shaposhnikov's retirement, as well as his deputy General-Lieutenant Nikolai F. Vatutin, took part in the discussions. All three agreed that there was an opportunity created by Paulus' necessity to employ less reliable Romanian divisions to guard his extended flanks. However, Zhukov argued that the Red Army was now strong enough to mount simultaneous counteroffensives at Stalingrad and against Heeresgruppe Mitte. He was particularly adamant that the Rzhev Offensive in August had nearly succeeded and that a second try with stronger forces would lead to the collapse of Heeresgruppe Mitte. Impressed by Zhukov's zealous optimism, on 26 September Stalin ordered the Stavka to plan two great winter counteroffensives to regain the initiative from the Germans. He ordered Zhukov to coordinate the Kalinin and Western Front offensive against the Rzhev Salient – designated Operation *Mars* – and for Vasilevsky to coordinate Operation *Uranus*, the offensive against Paulus' AOK 6 at Stalingrad. Both offensives were expected to begin in mid-October and two follow-on offensives, known as Operations *Jupiter* and *Saturn*, were envisioned to exploit the expected success of the initial offensives.

As a result of these discussions at the Stavka, Zhukov, Vasilevsky and Stalin agreed to a major reshuffle of the command structure on the Stalingrad axis. Eremenko remained in command of the Stalingrad Front but the Don Front was created to take over three armies in the northern area between the Don

1. 29 December 1941–7 January 1942: Zhukov's Western Front creates a 9-mile-wide (15km) breach between the German AOK 4 and the 4. Panzerarmee between Borovsk and Maloyaroslavets. Only remnants of a single German division occupy the gap. The Stavka orders Zhukov to advance directly through the gap to seize Vyazma, the key line of communications node for much of Heeresgruppe Mitte.
2. 15 January 1942: an even larger 25-mile (40km) gap is created between AOK 4 and 2. Panzerarmee. The German XL AK (mot.) is screening the Moscow–Warsaw highway.
3. 15–31 January 1942: the 43rd Army envelops Yukhnov, forcing much of AOK 4 to retreat. The German XIII AK forms a hedgehog defence around Yukhnov.
4. 18–22 January 1942: the Soviet 201st Airborne Brigade (1,643 troops) is scattered in landings near Znamenka.
5. 20–31 January 1942: General-Lieutenant Efremov's 33rd Army advances through the gap in the AOK 4 front, pushing aside the German XX AK.
6. 20 January 1942: the Soviet 5th Army captures Mozhaisk and advances along the Moscow–Warsaw highway toward Gzhatsk.
7. 27 January 1942: Belov's 1st Guards Cavalry Corps crosses the Moscow–Warsaw highway and advances toward Vyazma and links up with some paratroopers.
8. 27 January–1 February 1942: the 8th Airborne Brigade (2,081 troops) lands west of Vyazma but fails to cut the main German lines of communication.
9. 28 January 1942: the Kalinin Front's 11th Cavalry Corps reaches the edge of the Moscow–Warsaw highway, but is stopped by blocking units from 4. Panzerarmee.
10. 1 February 1942: the German 4. Panzerarmee launches a counterattack that isolates the 33rd Army.
11. 4 February 1942: Zhukov orders an all-out concentric attack on Vyazma with 33rd Army and Belov's cavalry, but 4. Panzerarmee repulses the offensive.
12. 17–23 February 1942: in one last bid to re-energize the offensive against Vyazma, Zhukov orders the 9th and 214th Airborne Brigades (7,373 troops) to drop south of Vyazma, but they fail to link up with the 50th Army.
13. 1–5 March 1942: Zhukov commits his last reserves to take Yukhnov, conducting a concentric attack with the 43rd, 49th and 50th Armies. AOK 4 is forced to abandon the city, but the Germans establish a strong ring around Efremov's trapped 33rd Army.
14. 25 April 1942: the Germans finally crush the isolated 33rd Army and most of the paratrooper units.

The Vyazma campaign, January–February 1942

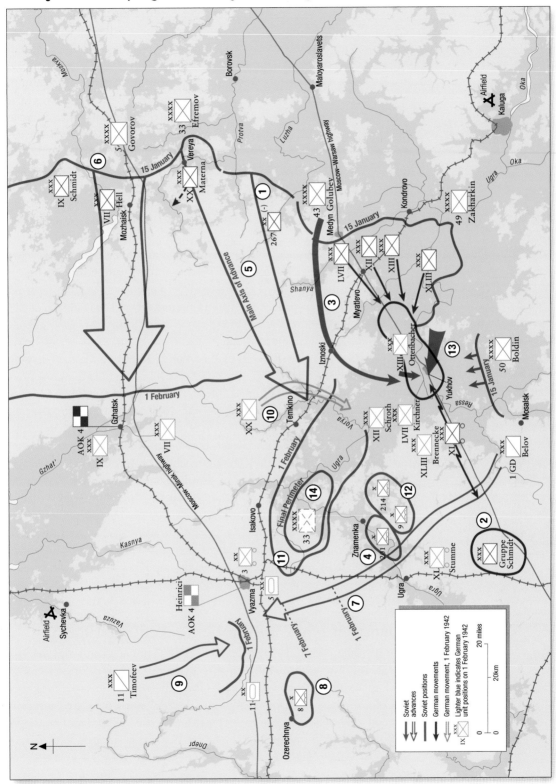

Borovsk

Maloyaroslavets

Airfield

Kaluga

Moskva

Govorov

XXXX
5

XXXX
33 Efremov

15 January

Vereya
Materna

XXX
XX

Protva

Luzha

Moscow–Warsaw highway

Oka

Ugra

Oka

XXX
IX Schmidt

XXX
VII Hell

Mozhaisk

Medyn Golubev

15 January

Kondrovo

XXXX
49 Zakharkin

1

XXXX
43

Main Axis of Advance

5

XX (-)
267

Shanya

3

XXX
LVII

XXX
XII

XXX
XIII

XXX
XLI.III

Myatlevo

Ottenbacher

Yuknov

13

XXXX
50 Boldin

15 January

Iznoski

XXX
XIII.I

Mosalsk

Ressa

1 February

Gzhatsk

AOK 4

XXX
VII

XXX
IX

Moscow–Minsk highway

Gzhat'

XXX
XX

Temkino

10

Vorya

XXX
XII Schroth

XXX
LVII Kirchner

XXX
Brennecke

XXX
XLI

XXX
XLI.III

XXX
Stumme

XLI

XXX
1 GD Belov

Kasnya

Isakovo

xx
3

11

XXXX
33

Final Perimeter

14

Ugra

Znamenka

4

x
20.1

x
214

12

x
9

xx
2.1

XXX
XL

XXX
Stumme

XXX
Gruppe Schmidt

2

Airfield
Sychevka

Heinrici

AOK 4

Vyazma

1 February

7 February

1 February

7

Ugra

Ugra

Vazuza

XXX
11 Timofeev

9

O
5

O
11

x
8

8

Ozerechnya

Dnepr

N

Z

Soviet
advances

Soviet positions

German movements

German movement, 1 February 1942

Lighter blue indicates German
unit positions on 1 February 1942

XXX
IX

20 miles

20km

0

0

29

Aleksandr M. Vasilevsky (1895–1977), who also served as a Stavka representative during 1942–43. Vasilevsky was more intellectual than Zhukov and a gifted General Staff officer, but lacked Zhukov's ruthless determination. Zhukov resented Vasilevsky's brilliant success in encircling and destroying the German AOK 6 at Stalingrad. (Author)

and Volga. Zhukov brought Rokossovsky in to take command of Don Front. Further west, Vatutin was given command of the South-western Front. Both Zhukov and Vasilevsky flew south to meet with Vatutin, Rokossovsky and Eremenko to begin transforming Operation *Uranus* from a concept in the Kremlin to a practical plan that would actually work on the battlefield. When all three front commanders informed Zhukov that their forces were too weak to consider a large-scale offensive within the next couple of weeks, Stalin demonstrated unusual forbearance and allowed the Stavka to spend the time necessary to gather replacements and supplies for a well-planned offensive. Although the initial concept for *Uranus* was a single envelopment by Vatutin's reinforced South-western Front against the 3rd Romanian Army, it was Eremenko who went to Moscow on 7 October and suggested a double envelopment of AOK 6 by using his Stalingrad Front as well. Eremenko was fed up with Zhukov ordering his troops into futile frontal attacks against prepared German defences and he believed that if he was given sufficient reinforcements he could break through the 4th Romanian Army south of Stalingrad and link up with Vatutin's spearheads behind Paulus' AOK 6.

Zhukov was not enamoured of Eremenko's recommendations and he ensured that the Stalingrad Front received fewer reinforcements than Vatutin's or Rokossovsky's fronts. Indeed, Zhukov ensured that his own pet project – Operation *Mars* – received priority over Operation *Uranus*. Overall, the initial attacks by Operation *Uranus* would be conducted by four Soviet armies with 20 divisions and seven mobile corps, while Operation *Mars* would have six armies with 46 divisions and five mobile corps. However, apparently unnoticed by Zhukov, the correlation of forces was more favourable for Operation *Uranus* than it was for Operation *Mars*, because of the weakness of the Romanian units. Zhukov made his last visit to the Stalingrad front three days before Operation *Uranus* began and then left Vasilevsky in charge while he returned north to handle *Mars*. The Soviet offensive caught the Romanian armies by complete surprise and routed them. On 23 November, Vatutin's and Eremenko's mobile groups met at Kalach, completing the encirclement of Paulus' AOK 6 in Stalingrad.

Operation *Mars*, November–December 1942

Owing to Stalin's confidence in Zhukov, the GKO provided both the Western and Kalinin fronts with reinforcements on a massive scale during the fall of 1942, including fresh guards divisions, two full-strength mechanized corps and one of the first artillery divisions. Victory seemed assured. Zhukov planned *Mars* to be a double envelopment, with the Kalinin Front attacking with two armies from the west while the Western Front attacked the east side of the salient with the heavily reinforced 20th Army. He expected his armoured spearheads – as at Khalkhin-Gol – to break through after some

heavy fighting and link-up in the middle, completing the encirclement and destruction of Model's vaunted AOK 9. However, Zhukov was too overconfident in planning *Mars* and distracted by operations around Stalingrad. This distraction was particularly evident in the minimal effort he put into *maskirovka*, which allowed the Germans to detect his build-up and reposition their forces.

When Operation *Mars* kicked off on 25 November 1942, the Soviet artillery preparation was largely ineffective due to blinding snowstorms and the German defences repulsed most of the initial attacks. Zhukov ignored reports that rifle divisions were being chopped to ribbons and ordered Konev to continue pouring his troops into the 'Rzhev meat grinder'. Even though the shock groups failed to achieve a real penetration of the German defences, Zhukov ordered his subordinates to commit their armour reserves prematurely, hoping that a large mass of armour could break open the front. Gradually, in spite of enormous losses, the 20th Army bullied its way 7 miles (12km) into AOK 9's eastern flank while the 41st Army advanced 22 miles (35km) into the western side of the salient. Despite being under enormous pressure, Walter Model fought desperately to maintain a continuous front and once his Panzer reserves began to arrive, he was able to mount several vicious counterattacks that cut off and demolished the Soviet spearheads. Konev's front lost the 6th Tank Corps and the 2nd Guards Cavalry Corps, while Purkaev lost the 1st Mechanized Corps and the 6th Rifle Corps. Although it was obvious after the first week that *Mars* was not proceeding well, Zhukov stubbornly kept issuing attack orders for three weeks until finally ending the offensive on 20 December.

Operation *Mars* was a total defeat for Zhukov and a great defensive victory for the Germans. Preoccupied with his duties as deputy supreme commander and the Stalingrad situation, Zhukov had paid little attention to terrain or the enemy facing his troops in the Rzhev Salient. During Operation *Mars*, the Kalinin and Western fronts had suffered over 335,000 casualties – 40 per cent of the attack force – as well as 85 per cent of their tanks. Six Soviet corps were virtually destroyed in the operation for no significant gains. Armeeoberkommando 9 held defiantly onto the Rzhev Salient, inviting further slaughter of Soviet armies. Yet perhaps the worst aspect of Operation *Mars* for Zhukov – who could overlook the losses – was that he had failed while Vasilevsky had succeeded with Operation *Uranus*. In Stalin's mind, the defeat of Operation *Mars* lowered his esteem of Zhukov's abilities as a field commander but he still recognized him as a competent military planner.

Leningrad, 1943

After his debacle at Rzhev, the GKO decided that Zhukov was better suited as a Stavka representative rather than commanding a single front and sent him to Leningrad again, where repeated Soviet offensives by Meretskov's Volkhov Front and General-Lieutenant Leonid A. Govorov's Leningrad Front had been unable to break the German siege. The key German defensive positions on the Siniavino Heights had withstood constant attacks during

1942, but they had to be taken in order to satisfy Stalin's resolve to relieve the siege of Leningrad as soon as possible. Meretskov was a competent staff officer and effective planner who had been made a Hero of the Soviet Union after breaking through the Finnish Mannerheim Line in 1940. Yet despite his professional skill, Meretskov lacked the ruthlessness of Zhukov and the GKO felt that this had undermined the two previous efforts to raise the siege, so Zhukov was sent to coordinate Operation *Spark*, the next joint offensive by the Leningrad and Volkhov fronts. Zhukov arrived at Meretskov's headquarters on 10 January 1943, two days before the offensive began, and had no role in the development of the plan.

Operation *Spark* began with a massive artillery barrage by both fronts on the morning of 12 January 1943. Unlike Zhukov, who had unimaginatively relied upon infantry-heavy shock groups in Operation *Mars*, Meretskov had learned from his previous defeats and formed mixed rifle, tank and engineer assault groups. He also had learned to use experienced formations and aggressive commanders – like General-Major Nikolai P. Simoniak – as his spearhead, as opposed to Zhukov's tendency to throw untrained recruits into a meat grinder. Despite stiff German resistance, Simoniak's division from the Leningrad Front linked up with troops from the Volkhov Front on 18 January, establishing a tenuous land link to Leningrad. On the same day, Zhukov was promoted to Marshal of the Soviet Union. Throughout the

Zhukov's command style: the relief of General-Major Tarasov, 14 December 1942

Zhukov received his officer training within a political system that believed that people were merely an expendable asset to be used in order to achieve its objectives. He also learned during the pre-war Stalinist purges that brutality and threats were effective tools in motivating subordinates to accomplish seemingly impossible tasks. Thus, bullying and a ruthless disregard for losses became a trademark of Zhukov's command style. During the fighting around Leningrad in September 1941, he ordered that all commanders who allowed retreats – along with their families – would be shot. Zhukov normally travelled with a small NKVD security detachment, which he occasionally used to arrest lower-ranking officers whom he perceived as cowards or slackers. Subordinates soon learned that an inspection visit from Zhukov could be dangerous. Even in the best of times, Zhukov rarely showed front-line camaraderie and preferred an aloof and menacing demeanour. However, Zhukov was also capable of failure and his Operation *Mars* against the Rzhev Salient proved an utter disaster in November–December 1942. When German counterattacks isolated the spearhead of General-Major German F. Tarasov's 41st Army, Zhukov ordered him to break through the German ring and rescue the two trapped corps. However, Tarasov failed to reach his encircled troops or to capture the key town of Belyi. Zhukov went to Tarasov's headquarters in a rage on 14 December 1942 and relieved him of command and personally took over the 41st Army, but also failed to accomplish the mission. Here, a red-faced Zhukov (1) is screaming at Tarasov (2), calling him a 'Trotskyite' and a coward, while Tarasov's staff cowers (3) in the background. Zhukov's bullying command style often forced subordinates to reinforce failed attacks until their units were burnt out and combat ineffective.

offensive, Zhukov's primary contribution was a constant barrage of threats against Meretskov and his subordinates to accelerate the pace of the advance. Simoniak's victorious troops were unable to seize all of the Siniavino Heights but Zhukov finally met his match when he tried to bully Simoniak into another futile assault to take the high ground. Telephoning Simoniak, Zhukov demanded to know why he called off the attack:

> Simoniak: The approach is through a marsh. The losses would be great and the results small.
> Zhukov: Trotskyite! Passive resister! Who are those cowards of yours? Who doesn't want to fight? Who needs to be ousted?
> Simoniak: There are no cowards in the 67th Army!
> Zhukov: Wise guy. I order you to take the heights.
> Simoniak: Comrade Marshal, my army is under the command of the Leningrad Front commander, General Govorov. I take orders from him.

Encouraged by the partial success of Operation *Spark*, Zhukov hoped to inflict an even greater defeat on Heeresgruppe Nord. Marshal Timoshenko, now in charge of the North-western Front, recommended a winter offensive to crush the vulnerable German salient at Demyansk and Zhukov decided to expand this plan into a full-blown multi-front offensive involving Govorov's and Meretskov's forces, as well. He developed Operation *Polar Star*, with the idea that the Leningrad and Volkhov fronts would renew their efforts to take the Siniavino Heights in mid-February, but this was actually intended as a supporting effort to draw in German reserves. Once Heeresgruppe Nord committed everything it had to hold this key terrain, Timoshenko would attack and blast a hole in the German line between Demyansk and Staraya Russa. In the best tradition of deep battle, Timoshenko would then commit a strong mobile group based on 1st Shock Army to envelop Heeresgruppe Nord by seizing Luga, Pskov and Narva, leading to a complete German collapse in north Russia.

Zhukov diverted considerable reinforcements to build up Timoshenko's shock groups, including two artillery divisions and many heavy artillery regiments from the Reserve of the Supreme Command (RVGK). The diversionary attacks around Leningrad began on 10 February and *Polar Star* was set to begin five days later. Although the Soviet attacks at Krasny Bor and on the Siniavino Heights made modest gains, the German lines held. Poor weather and supply difficulties delayed the start of Timoshenko's attack and the Germans surprised Zhukov by beginning an evacuation of the Demyansk Salient on 19 February. Zhukov immediately ordered Timoshenko to attack with the forces available but the result was a disjointed effort that failed to strike any heavy blows on the retreating Germans but suffered 33,000 casualties in the pursuit. Once the Demyansk Salient was evacuated, the German AOK 16 was able to establish a new, stronger line by late February that Timoshenko's armies could not break. Rather than accept that *Polar Star* had failed, Zhukov ordered Timoshenko, Govorov and Meretskov

to attack again on 5 March. By this point, all the Soviet armies involved were exhausted and the results were predictable – failure to seize key terrain and heavy casualties. Zhukov allowed the offensive to continue for several weeks until it burnt itself out. He then recommended that Konev replace Timoshenko as front commander.

After two months in northern Russia, Zhukov had failed to encircle any significant German units or inflict any major defeats on Heeresgruppe Nord. Instead, the bulk of the credit for the partial success of Operation *Spark* lies with Meretskov and Govorov. However, Manstein had inflicted a serious defeat upon the South-western and Voronezh fronts near Kharkov and on 16 March 1943 Stalin ordered Zhukov to go to Kursk to contain the German counteroffensive.

Stavka coordinator, March 1943–February 1944

By the time that Zhukov arrived at the headquarters of the Voronezh Front in Bobyshevo, Manstein's counteroffensive was coming to a close and Soviet forces were forming a new front north of Belgorod. Vatutin was made the new commander of the Voronezh Front and Zhukov worked with him to shuffle three new armies from RVGK reserves into the front line. By late March, the rainy weather season greatly reduced mobile operations and brought a temporary stalemate. Zhukov and Vatutin realized that Manstein would renew his offensive once the spring weather improved, with the likely objective of seizing Kursk. However, Zhukov also advised Stalin that he expected the Germans to make another effort against Moscow after taking Kursk. Returning to the Kremlin on 12 April to attend a Stavka conference with Stalin, Zhukov and Vasilevsky both urged caution. Setbacks like Operation *Mars* and *Polar Star* had convinced him that the Red Army should avoid the kind of premature offensives that squandered Stavka reserves for minimal gains. Instead, they urged that Soviet armies should shift to the defensive around Kursk, build a defence in depth backed by huge reserves and wait for the inevitable German offensive. Although Zhukov understood that the German Army still had potent offensive capabilities, he was convinced that the Red Army could hold Kursk against the best that the Germans could dish out and once their armour was expended, launch a devastating counteroffensive. Most of the other senior Soviet commanders, including Rokossovsky and Vatutin, also supported this appreciation. Stalin was not so sure that the Red Army was ready to stop a fullly fledged German summer offensive in open terrain – it had yet to do so – but he grudgingly accepted the recommendations from Zhukov and the Stavka.

Since the central front was temporarily quiet, the Stavka sent Zhukov to the North

Zhukov, in his role as Stavka representative, listening to an operational brief. During 1943 Zhukov held no front-line commands and his role during the middle part of the war was more circumscribed than in the beginning or end phases. (Courtesy of the Central Museum of the Armed Forces Moscow via Nik Cornish)

Caucasus Front on 18 April 1943 to supervise an offensive against the German AOK 17 in the Kuban bridgehead. Although this was a minor incident in his career, it later figured prominently in his memoirs because he mentions Commissar Leonid Brezhnev and Andrei Grechko, who both rose to top positions in the post-war Soviet Union. After witnessing the strength of the German defences in the Kuban, he recommended to the Stavka that the North Caucasus Front should limit its attacks in order to conserve RGVK reserves for the coming battle of Kursk. Zhukov returned to Kursk in early May, when the Stavka expected the German offensive to begin. The Stavka assigned Zhukov as their representative to Rokossovsky's Central Front and Vasilevsky was given the same role at Vatutin's Voronezh Front.

The Stavka tasked the Western (General-Colonel V. D. Sokolovsky), Central (Rokossovsky) and Bryansk (General-Colonel M. M. Popov) Fronts to develop a plan for a counteroffensive to eliminate the German-held Orel Salient as soon as the German offensive had spent itself. It was Zhukov's responsibility to supervise this plan, named Operation *Kutuzov*. Similarly, the Voronezh Front was tasked to develop a plan to retake Belgorod and Kharkov, which became Operation *Rumyantsev* with Vasilevsky responsible for it. Even though the Stavka regarded Manstein and Heeresgruppe Süd as the primary threat to Kursk, Zhukov remained obsessed with inflicting a catastrophic defeat on Heeresgruppe Mitte and particularly Walter Model – whose defeat of Operation *Mars* had humiliated Zhukov. The Western Front's 11th Guards Army under General-Lieutenant Ivan K. Bagramyan – who had impressed Zhukov as a staff officer in the Kiev MD before the war – was built into a massive battering ram to tear through the weaker northern part of the Orel Salient, held by the 2. Panzerarmee.

By this point in the war, the GKO relied upon Zhukov and Vasilevsky as the primary offensive coordinators to supervise and direct multi-front operations. However unlike an army group commander such as Manstein, Zhukov had no significant staff of his own to plan operations, analyze intelligence or manage supplies. Instead, Zhukov had just a few General Staff officers in his personal entourage and had to work through the staff organizations of subordinate fronts. Many accounts give Zhukov credit for developing plans such as Operation *Uranus* and the Soviet counteroffensives after Kursk, but the broad outlines of these operational plans, assigning axes of advance and basic objectives, were done in the General Staff's Operations Directorate led by General Aleksei I. Antonov in Moscow. Operational planning in the Red Army was a committee effort – which helped to avoid blame when failures occurred – not the result of an individual commander's judgement. Once assigned a mission by the Stavka, each front was responsible for turning this guidance into a workable plan, by designating units involved, specific schemes of manoeuvre, timing and logistic requirements. Zhukov's role was to meet with front- and army-level commanders, review their plans for upcoming operations, ensure that these plans satisfied Stavka objectives, and then recommend necessary changes to improve the prospects for success. He also decided how to allocate

reinforcements from the RVGK reserves. In 1943, Zhukov's primary role was supervisory and intended to ensure the smooth cooperation of multi-front operations to accomplish a common objective.

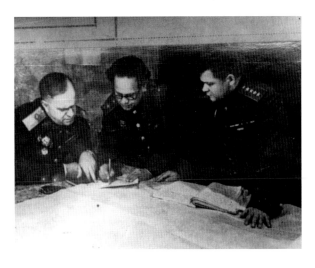

However, Marshal Zhukov was not satisfied with constraining himself to an advisory role and frequently became involved in tactical details down to the level of division, which his subordinate front commanders viewed as disruptive micromanagement. The martinet style that Zhukov employed to whip his cavalry regiment into shape now reappeared and was used to coerce staff officers, who were rarely well regarded by Zhukov. Although Vatutin and Rokossovsky were perfectly competent to organize their defensive sectors in the Kursk Salient, Zhukov cast his eyes on the RVGK reserves that were gathered behind the salient to form the Steppe Front under Ivan Konev. These forces comprised the powerful 5th Guards Army and 5th Guards Tank Army, which the Stavka wanted to retain under their control until it was time to commit them for the main counteroffensive. The Stavka gave Zhukov the authority to decide where and when these reserves would be committed – a critical decision.

The Germans delayed the onset of their offensive, designated Operation *Zitadelle*, until early July in order to build up their depleted Panzer units, but this allowed the Red Army to amass an unprecedented amount of troops, tanks and artillery in the Kursk Salient. When it became obvious that the German offensive was about to begin on the morning of 5 July, Zhukov ordered Rokossovsky to fire a strong artillery counter-preparation to disrupt Model's attack. Thereafter, Zhukov played only a supporting role in the defensive phase of the battle of Kursk and instead focused on final preparations to implement *Kutuzov* and *Rumyantsev* as soon as *Zitadelle* had culminated. When Model called off AOK 9's role in the offensive and shifted to the defence, Zhukov ordered Operation *Kutuzov* to begin on 12 July. Model was expecting this attack and still had plenty of armour in reserve. Although Bagramyan's 11th Guards Army achieved a 45-mile (72km) deep penetration of the northern flank of the Orel Salient, Model was able to fight a classic, month-long delaying action that inflicted a seven-to-one casualty rate upon the three attacking Soviet fronts. *Kutuzov* ended with the liberation of the entire Orel Salient, but no significant German units were encircled or destroyed.

Right after *Kutuzov* began, the Stavka sent Vasilevsky to the South-western Front on 13 July to coordinate a diversionary offensive on the Mius River, set to begin in four days. Zhukov went to Vatutin's headquarters to coordinate Operation *Rumyantsev* – the counteroffensive against Manstein's Heeresgruppe Süd – to be conducted by the Voronezh and Steppe fronts. Stalin wanted to begin *Rumyantsev* on 23 July but for once, Zhukov's

Zhukov going over planning for operations around Kiev in November 1943 with General Nikolai Vatutin, commander of the 1st Ukrainian Front and his chief of staff General-Lieutenant Aleksandr Bogoliubov. Vatutin had originally been Zhukov's chief of staff in 1940 and they worked fairly well together. (Courtesy of the Central Museum of the Armed Forces Moscow via Nik Cornish)

recognized that the front-line units needed time to replace losses and conduct resupply. He requested an eight-day delay and Stalin accepted it. The attacks on the Mius River succeeded in diverting much of Manstein's armour to the south so when Operation *Rumyanstev* began on 3 August, it achieved rapid although costly success against the 4. Panzerarmee. Afterwards, Zhukov preferred to replace losses and conduct resupply before pushing on to the Dnepr River, but Stalin was adamant that the Red Army would immediately pursue the defeated Heeresgruppe Süd and seize bridgeheads across the river. On 9 September, Zhukov and Vatutin rapidly put together a plan for an immediate advance toward the Dnepr with General-Lieutenant P. S. Rybalko's fresh 3rd Guards Tank Army. Rybalko's rapid advance caught Manstein by complete surprise and before the Germans could establish a new defensive line behind the river, Soviet tankers seized a bridgehead at Bukrin on 22 September. Zhukov's forces reached the Dnepr along a 150-mile (240km) front between Kiev and Kremenchug and faced only scattered resistance from the German AOK 8 and 4. Panzerarmee. Konev was able to seize a bridgehead near Kremenchug while Vatutin seized a second bridgehead north of Kiev at Lyutezh. Thus by late September 1943, Zhukov's forces had already disrupted German plans to build an impregnable defensive barrier behind the Dnepr.

At this point, the initiative began to slip from Zhukov's grasp as the Germans launched desperate counterattacks to eliminate Vatutin's two bridgeheads and Stalin increased the pressure by ordering Zhukov to immediately begin preparations to capture Kiev. However, only a small part of Vatutin's and Konev's forces were across the Dnepr and the Germans had both bridgeheads thoroughly surrounded. Zhukov pushed Vatutin to fight his way out of these tiny footholds but two attacks failed with heavy losses. Vatutin was angry at being ordered to conduct one futile attack after another and successfully argued with Zhukov to call off the senseless frontal attacks and try something else. For once Zhukov listened, probably because it was Vatutin. Meanwhile, Konev achieved more success from his bridgehead at Kremenchug and routed part of AOK 8.

Vatutin proposed a bold shifting of Rybalko's 3rd Guards Tank Army and more infantry to the Lyutezh bridgehead, combined with a strong *maskirovka* effort to suggest another offensive to break out of Bukrin. Manstein bought it. On 3 November, Vatutin conducted a breakout from the Lyutezh bridgehead that routed a German infantry corps and led to the liberation of Kiev three days later. Zhukov was among the first senior officers to return to the city and noted its devastation. After Kiev, Zhukov had his eye on the German salient around Cherkassy, which Hitler adamantly refused to abandon. Since Stalingrad, Zhukov had been eager to conduct an encirclement operation of his own that would lead to a major haul of German prisoners, but each time an opportunity presented itself, other circumstances forced Zhukov to change his plans. In this case, Manstein was given major reinforcements after the fall of Kiev and he launched a counteroffensive in mid-November against Vatutin's 1st Ukrainian Front that regained some

ground. Zhukov was forced to devote all his energy toward countering this threat and the German counteroffensive achieved only limited success. In mid-December, Zhukov returned to Moscow and pitched his plan to push back Manstein's 4. Panzerarmee from its gains west of Kiev and encircle part of AOK 8 in the Cherkassy Salient.

Looking for the perfect encirclement, January–March 1944

By the end of 1943, Zhukov was responsible for coordinating two fronts that had one million troops in a total of 17 armies with 128 divisions and 15 tank/mechanized corps. Three of the five Soviet tank armies and more than one-third of the Red Army's armour were within his jurisdiction. Kursk had given Manstein only a taste of what the new Red Army could accomplish but he saw its full capabilities displayed in the opening days of Vatutin's Zhitomir–Berdichev offensive that began on 29 December 1943. Whereas previous Soviet offensives had difficulty penetrating prepared German defences, Vatutin's nine armies simply overwhelmed Manstein's left flank and pushed back the 4. Panzerarmee toward the Dniester River. Konev also continued to pound away at Manstein's right flank, pushing back AOK 8 and further exposing the German salient at Korsun. Only two weeks after Vatutin began the Zhitomir–Berdichev Offensive, Zhukov told him to call it off and to prepare to form the western pincer against the Korsun Salient. Zhukov also instructed Konev to wrap up his attacks around Kirovograd and to prepare to form the eastern pincer. Zhukov's plan – which was quickly approved by the Stavka – was simply to conduct a double envelopment of the German forces in the Korsun Salient and annihilate the trapped forces within about a week. Vatutin would attack with 6th Tank Army in the west and Konev with 5th Guards Tank Army in the east and they would each advance 25–30 miles (45–50km) to meet at Zvenigorodka. The unusual feature of Zhukov's plan was that although he claimed to be resurrecting Tukhachevsky's pre-war theory of deep battle, the Korsun operation was very shallow and sought only tactical objectives.

Zhukov was impatient to get the operation going before either the Germans evacuated the salient or Stalin directed him to go after some other prestige objective, but the result was that the logistic preparation was inadequate and all three tank armies were seriously under strength. Nevertheless, the offensive began on 25 January 1944 and within three days the Soviet armoured spearheads had linked up and isolated two German corps with 56,000 troops. Oddly, Zhukov had not really considered the Germans' making a serious effort to relieve the trapped forces and was

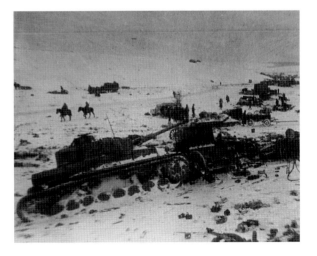

German vehicles and equipment litter the battlefield in the Korsun Pocket. Zhukov conducted a professional encirclement that trapped and decimated six German divisions in February 1944, but he failed to adequately prepare for a breakout attempt. Zhukov later tried to conceal the fact that over 40,000 German troops escaped from the Korsun Pocket. (Courtesy of the Central Museum of the Armed Forces Moscow via Nik Cornish)

caught by surprise when Manstein scraped up two weak Panzer corps to push toward Korsun. Nor had Zhukov seriously coordinated with the Red Air Force to prevent the Luftwaffe from providing aerial resupply to the pocket. In his memoirs, Zhukov lamely claimed that he had the flu when Manstein's relief effort began on 1 February and the destruction of the pocket was impeded by the shortage of artillery ammunition. On 8 February, Zhukov offered surrender terms to the trapped German forces, but they not only ignored him but began to fight their way towards the relief force. As Manstein's relief forces slowly advanced toward the pocket, Stalin became concerned about inadequate coordination between Vatutin and Konev and on 12 February placed Zhukov in direct command of the blocking forces around the town of Lysyanka. Zhukov found himself in charge of a hotchpotch of units from the 5th Guards Tank Army and the 27th Army and was able to stop the relief force just short of a link-up. However, Zhukov was surprised when the Germans trapped inside the pocket fought their way out on the night of 16–17 February. Some 40,000 Germans escaped through Zhukov's lines – without their heavy equipment – leaving 19,000 dead or prisoners within the pocket. Korsun was a significant tactical victory in smashing five German divisions but Zhukov was loath to reveal to Stalin that the bulk of the trapped enemy had escaped and he and other Soviet commanders lied about the German breakout. Konev and Zhukov also suffered a falling out over responsibility for the failure to contain the German breakout and their relationship deteriorated.

1st Ukrainian Front, March–May 1944

Although the battle of the Korsun Pocket had not turned out as expected, Zhukov recognized that Manstein's Heeresgruppe Süd was in poor shape after months of continuous retreats and that neither AOK 8 nor Hube's 1. Panzerarmee would be able to stop another joint offensive by Vatutin's and Konev's commands. Yet less than a week before the offensive was set to begin, Ukrainian partisans mortally wounded Vatutin on 28 February. Stalin directed Zhukov to take personal command of the 1st Ukrainian Front for the upcoming operation. At the start of the offensive which began on 4 March, Zhukov commanded five combined arms armies and three tank armies, which made it easily the strongest formation under one commander in the Red Army.

Unlike the Korsun operation, this offensive was much better prepared and executed. Zhukov used two infantry armies to tear a 30-mile (50km) gap in the boundary between the 4. and 1. Panzerarmeen, then pushed the 3rd Guards Tank Army and 4th Tank Army into the breach to exploit. It was a classic Soviet offensive, delivered with power and speed that rapidly overwhelmed the German formations in its path. The 4. Panzerarmee was badly defeated and fell back 85 miles (140km), increasing the distance between it and Hube's 1. Panzerarmee. Simultaneously, Konev's forces attacked the boundary between 1. Panzerarmee and its right neighbour, AOK 8. Within a week, both of Manstein's flanks were in retreat and Zhukov realized that he had an

opportunity to isolate and destroy an entire German army. He recommended to the Stavka that he be allowed to advance south across the Dniester River to occupy Chernovtsy and thereby isolate Hube's command. The Stavka approved the plan.

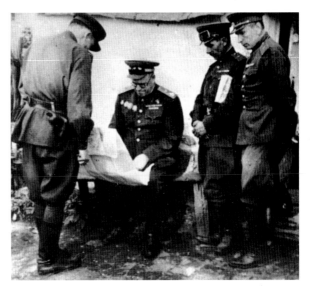

Hitler tried to break the rapid pace of Zhukov's offensive by declaring selected towns such as Tarnopol as fortresses, and Zhukov obliged him by diverting significant forces to reduce each garrison. Bypass was not in Zhukov's lexicon. The battle for Tarnopol went on through mid-March, as 4. Panzerarmee managed to scrape up some Panzer units to counterattack Zhukov's right flank. However, Zhukov used the slowdown in the offensive to reposition all three of his tank armies in the 60-mile (100km) area between the German hedgehogs at Tarnopol and Proskurov and then he unleashed them on the morning of 20 March. The thin German covering forces were blown away and the 1st Tank Army advanced southwards to cross the Dniester River on 24 March. Hube's 1. Panzerarmee suddenly found itself in a salient near the town of Kamenets-Podol'skiy, with both flanks hanging in the air. Within two more days, Zhukov's armour overran the towns of Chernovtsy and Kamenets-Podol'skiy, while Konev committed the 6th Tank Army across the Dniester to complete the encirclement. By 28 March, Hube's 1. Panzerarmee with over 200,000 troops in 23 divisions were surrounded and their destruction seemed certain. Once the pocket was created, Zhukov wasted no time ordering his 1st Guards, 18th and 38th Armies to pound its northern and eastern sides, while the 3rd Guards Tank and 4th Tank Armies tried to push in the western side.

Zhukov and his staff in the Ukraine, probably during the Lvov–Sandomierz operation in the summer of 1944. While acting as a Stavka representative, Zhukov was hindered by the lack of a full staff and had to make do with only a few aides. Note the rare appearance of Zhukov wearing reading glasses. (Author)

Despite the seeming hopelessness of the situation for Hube's forces, Zhukov was to learn what the Germans had discovered in 1941 – that it is difficult to seal off a pocket effectively with armour units. Zhukov had expected some kind of breakout effort from the pocket and he believed Hube would head southwards across the Dniester into Romania, so he positioned strong blocking forces in this area. However, Hube proved to be a master of improvisation and organized a breakout to the west, which was thinly held by 4th Tank Army. Despite having only 35 tanks and limited fuel, Hube was able to encircle the 10th Guards Tank Corps at Kamenets-Podol'skiy and then advance steadily westwards through the 4th Tank Army. Hube's forces were able to capture a number of intact bridges that aided their movement westward. Meanwhile, Manstein persuaded Hitler to dispatch II SS-Panzerkorps from Holland to act as a relief force to link up with Hube's forces south of Tarnopol. It was not until 31 March that Zhukov became aware that the Germans were escaping to the west instead of to the south.

Zhukov had three tank armies between Hube and II SS-Panzerkorps, but the Soviet armour units were reduced to less than 100 tanks each and had little infantry. Poor weather – which had often aided Zhukov in the past – now hindered him as a mix of blizzards and muddy roads made it impossible to reposition his infantry armies to where they were needed on the west side of the pocket. Incredibly, Hube's pocket moved steadily westward, pushing Zhukov's depleted armour out of the way while the Soviet infantry struggled behind them in pursuit. On 6 April, Hube's 1. Panzerarmee linked up with II SS-Panzerkorps on the Seret River and the battle of Hube's Pocket ended with the escape of the bulk of this army. Zhukov's 1st Ukrainian Front had missed a golden opportunity to eliminate an entire German Panzer army and had to settle for merely occupying terrain. Furthermore, unlike the breakout from the Korsun Pocket, Hube's army escaped relatively intact so it could resume its place in the new German front line.

As a postscript to Hube's Pocket, Zhukov began an all-out effort with his 60th Army to eliminate the 4,600 Germans under siege in the fortress of Tarnopol. Manstein had been relieved for his failure to stop Zhukov's offensive and replaced with Walter Model, who took over the renamed Heeresgruppe Nordukraine. Model used II SS-Panzerkorps to make a desperate relief effort to Tarnopol on 11 April, but this time, Zhukov was able to block the relief force 7 miles (11km) from its objective and then annihilate the German garrison.

Soviet summer offensives, June–August 1944

After the escape of Hube's 1. Panzerarmee, the Soviet offensive in the north Ukraine came to a close and Zhukov was recalled to the Stavka on 22 April to discuss plans for the upcoming Soviet summer offensives. It was decided that since the Germans had reinforced Heeresgruppe Nordukraine, the main effort would be shifted to Byelorussia, where four fronts could attack Heeresgruppe Mitte. In conjunction with Antonov and Vasilevsky, Zhukov developed the broad outline of the plan for Operation *Bagration*, while detailed planning was delegated to the front commanders. By this point, the Stavka knew that it was German doctrine to transfer reserves from quiet sectors in order to prevent a breakthrough, but now the Stavka counted on this to accomplish their objectives. Once the OKH stripped Heeresgruppen Nordukraine and Nord of reserves to aid Heeresgruppe Mitte, the Stavka would launch major offensives against these army groups as well, in order to precipitate a general collapse. Unlike previous jury-rigged Soviet offensives, *Bagration* was well planned, provided with adequate logistic support and concealed by a masterful *maskirovka* effort.

Just prior to the start of *Bagration*, the Stavka sent Zhukov to coordinate the two southern fronts (1st Byelorussian under Rokossovsky and 2nd Byelorussian Front under General-Colonel Georgy F. Zakharov), while Vasilevsky was sent to coordinate the two northern fronts (1st Baltic and 3rd Byelorussian). The Stavka also sent its chief of operations, General Sergei M. Shtemenko, to assist Zhukov. Arriving at Rokossovsky's headquarters on

5 June, Zhukov was responsible for coordinating the massive influx of reinforcements and supplies for the offensive. He also received back-briefs from subordinate army commanders to ensure that their tactical planning was adequate to achieve their mission objectives. Since he knew that Rokossovsky's 1st Byelorussian Front was the main effort in his sector but Zakharov would play only a supporting role, Zhukov fobbed off his supervisory responsibilities for the 2nd Byelorussian Front on Shtemenko. Zhukov concentrated 45 rifle divisions, nine cavalry divisions, three tank/mechanized corps and five artillery divisions into Rokossovsky's over-sized command, while Zakharov had to make do with only 22 rifle divisions and minimal armor support.

When *Bagration* began on 23 June, Rokossovsky's front attacked AOK 9 near Bobruisk. Although they were outnumbered four to one in manpower and six to one in tanks, AOK 9 put up a tough fight and repulsed Rokossovsky's initial attacks. However, the weight of Soviet artillery finally blasted two holes in the AOK 9 front line and Rokossovsky's armour and cavalry poured through the gaps to encircle 40,000 German troops east of Bobruisk. Within a week, AOK 9 was crushed and its remnants falling back towards Minsk. The German disintegration occurred so rapidly and Soviet units advanced so quickly that Zhukov had difficulty coordinating the encirclement of Minsk with Vasilevsky's forces, which enabled some remnants of Heeresgruppe Mitte to escape westwards. Nevertheless, Minsk was liberated on 3 July and Heeresgruppe Mitte fell back in disorder toward the Polish border.

Once *Bagration* had succeeded, Zhukov returned to Moscow to consult with Stalin and was then sent to coordinate the offensive by Konev's 1st Ukrainian Front against Heeresgruppe Nordukraine. Zhukov arrived at Konev's headquarters on 11 July, just two days before the offensive began, so he had little time to review preparations. Unlike Byelorussia, the Germans were expecting an offensive against Lvov and Konev's forces had difficulty achieving a penetration of the thick enemy defences. After several days' fighting, Konev was able to commit his three tank armies and encircled 30,000 Germans at Brody and liberated Lvov by 27 July. Afterwards, Heeresgruppe Nordukraine fell back into Poland and the Lvov–Sandomierz offensive succeeded in clearing the enemy from Galicia and gained a bridgehead over the Vistula River at Sandomierz by 31 July. Despite an advance of over 150 miles (240km) in just 18 days against tough enemy resistance, Zhukov was highly critical of this operation in his memoirs and claimed 'not everything was done properly when the operation was being prepared'. He claimed that Konev had conducted inadequate reconnaissance and failed to coordinate his infantry and tank formations properly. These criticisms appear driven by continuing rancour between Zhukov and Konev over the Korsun operation and an effort to suggest that Konev lacked Zhukov's operational-level expertise.

After spending six weeks with Konev's front, Zhukov was ordered by Stalin to fly to supervise Marshal F. I. Tolbukhin's 3rd Ukrainian Front, which was in the process of overrunning eastern Romania. By the time that Zhukov

arrived at Tolbukhin's headquarters on 25 August, the Romanians had already surrendered and Stalin ordered preparations for the 3rd Ukrainian Front to continue on into Bulgaria. However, the Bulgarians had no stomach for a suicidal war with the Soviet Union and surrendered on 5 September. Zhukov's role in this theatre was in directing the initial stages of occupation and to expedite the integration of Romanian and Bulgarian satellite troops – now fighting against the Germans – into the Soviet order of battle.

Vistula–Oder Offensive, January 1945

Zhukov returned to Moscow in late September 1944 and spent most of the autumn working with Antonov and the General Staff preparing the plans for the final offensives against Germany. Once the depleted front-line Soviet armies were replenished, the next set of offensives would begin with a breakout from the three Soviet-held bridgeheads over the Vistula to destroy Heeresgruppe A in central Poland. The 1st Byelorussian Front and Konev's 1st Ukrainian Front, reinforced to over 2 million troops, would act as battering rams to smash the German centre and begin the final advance on Berlin, while the flanking fronts would eliminate the German armies in East Prussia and Silesia. Now that Soviet armies had repeatedly demonstrated their ability to conduct successful offensives, the Stavka no longer saw the need to dispatch representatives to coordinate multi-front operations. Stalin offered Zhukov command of the 1st Byelorussian Front, which would clearly be at the forefront of the final victory, while Rokossovsky was moved to the 2nd Byelorussian Front.

Zhukov took command of this front on 18 November 1944. This formation comprised over 1 million troops in eight combined arms armies and two tank armies, deployed along a 143-mile (230km) front along the Vistula River. The 1st Polish Army was included in Zhukov's command, to create the illusion of Soviet-Polish cooperation in the 'liberation' of Poland. Zhukov also had three of the best Soviet combat leaders in charge of his strike forces: Katukov at the head of 1st Guards Tank Army, Simoniak in 3rd Shock Army and Chuikov in 8th Guards Army. His relationship with each of these commanders was strained, including threats he made to Katukov to get rid of his 'field wife' or he would send the NKVD to remove her. Adding to this rancour, Zhukov began to hypocritically flaunt his own 'field wife' – the young medical officer Lieutenant Lidia Zakharova. Zhukov continued his relationship with Zakharova for several years after the war.

The 1st Byelorussian Front had two bridgeheads over the Vistula, at Magnuszew and Pulawy, which were

Soviet infantry in an assembly area before an offensive. Zhukov made little effort to visit front-line troops or understand their privations. Thanks to his disregard for losses, by 1945 the Red Army was running out of infantrymen. (From the fonds of the RGAKFD at Krasnogorsk via Nik Cornish)

The Vistula-Oder Offensive, 14–17 January 1945

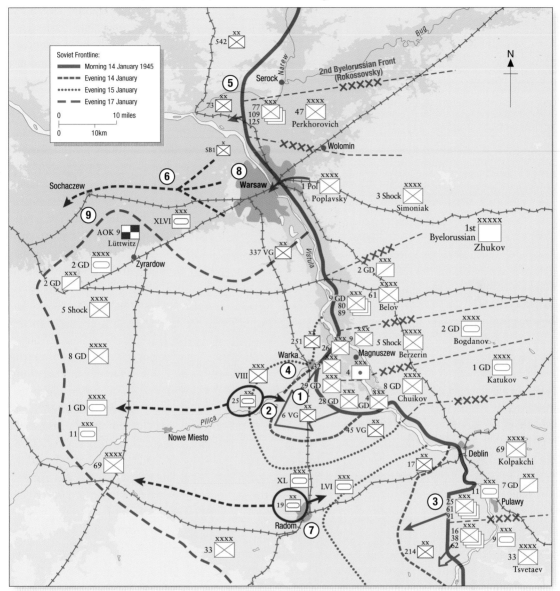

14 January 1945

1. 0630hrs: the 5th Shock Army and 8th Guards Army begin attacking out of the Magnuszew bridgehead, destroying the 6. Volksgrenadier Division. The German VIII AK begins to disintegrate.
2. 1030hrs: the German XL Panzerkorps counterattacks with two Panzer divisions, but splits its effort against both Soviet bridgeheads. The weak counterattacks fail.
3. The Soviet 33rd Army attacks out of the Pulawy bridgehead and achieves a deep penetration in the 214. Infanterie-Division's sector.

15 January 1945

4. Zhukov commits the 2nd Guards Tank Army across the Pilica River.
5. The Soviet 47th Army attacks the 73. Infanterie-Division.

16 January 1945

6. Soviet and Polish forces begin to encircle Warsaw, causing AOK 9 to abandon the city.
7. The 69th Army captures Radom.

17 January 1945

8. 1200hrs: the 1st Polish Army advances into a vacant Warsaw.
9. 2nd Guards Tank Army captures Sochaczew. Zhukov has achieved a complete breakthrough and the remnants of AOK 9 retreat westwards.

primed as springboards for a breakout. The logistic effort that went into preparing for the offensive was unprecedented by Soviet standards – for once there would be plenty of fuel and ammunition to conduct sustained operations. Opposite Zhukov's forces, Heeresgruppe A had the rebuilt AOK 9, which consisted of only seven infantry and two Panzer divisions under General der Panzertruppen Smilo Freiherr von Lüttwitz. The German forces were outnumbered five to one and their mobility was constrained by fuel shortages. Furthermore, Hitler and the OKH did not expect a major Soviet

Zhukov conferring with Konstantin Rokossovsky, his former division commander. Together with Konev, Zhukov and Rokossovsky formed the troika of Soviet front commanders who played the leading role in the final year of the war on the Eastern Front. (Courtesy of the Central Museum of the Armed Forces Moscow via Nik Cornish)

offensive in the centre but rather against East Prussia and Silesia, so they strengthened the flanks at the expense of Heeresgruppe A. The cold weather also favoured a Soviet offensive, since the ground and rivers were frozen hard but unlike Russia, snow cover was modest. Konev's 1st Ukrainian Front, on Zhukov's left flank, attacked first, followed by Rokossovsky's 2nd Byelorussian Front on his right. Once the German front was reeling from these blows, Zhukov would attack in the centre.

At 0830hrs on 14 January, Zhukov's forces began their breakout from the Magnuszew and Pulawy bridgeheads under the cover of an 25-minute artillery barrage that deluged 315,000 rounds on the German positions, followed by intense air attacks. The two German infantry divisions guarding the Magnuszew bridgehead failed to thin out their front-line trenches and were obliterated by the bombardment. Zhukov had also learned from

Zhukov inspecting the captured fortress of Brest in the autumn of 1944. Note the M3A1 scout car as part of his security detail and the presence of Lieutenant Lidia Zakharova (left), his mistress. (Courtesy of the Central Museum of the Armed Forces Moscow via Nik Cornish)

Beginning in mid-1944, Zhukov amassed unprecedented amounts of rocket artillery to achieve initial shock effect in his offensives. Eventually, he was able to amass up to 1,000 rocket launchers, which smothered German defences in high explosives. (From the fonds of the RGAKFD at Krasnogorsk via Nik Cornish)

previous experience how to overcome German minefields and he assigned two or three assault pioneer battalions to each attacking rifle corps, enabling rapid breaching of the German obstacle belt. Lüttwitz had two Panzer divisions in reserve but instead of amassing them, he committed one against each of the Soviet bridgeheads. Zhukov had little difficulty fending off these feeble counterattacks and his troops advanced 20 miles (32km) on the first day. Zhukov committed the 2nd Guards Tank Army on the second day and it rapidly pushed into the collapsing centre of AOK 9. Meanwhile, the Soviet 47th Army and 1st Polish Army began enveloping XLVI Panzerkorps' position at Warsaw, which caused the Germans finally to evacuate the demolished ruins of the city. In just four days, Zhukov's powerful offensive crushed the ill-fated AOK 9 and, combined with Konev's success to the south and Rokossovsky's to the north, resulted in a rapid collapse of the German defences in Poland. Hitler immediately relieved Josef Harpe as commander of Heeresgruppe A and Lüttwitz as commander of AOK 9, but the situation was beyond retrieval. Zhukov's troops took Warsaw on 17 January, followed by Lodz two days later. The Vistula–Oder Offensive was one of the best-planned, best-executed Soviet offensives of the war and Zhukov's greatest victory against the Wehrmacht. His forces shattered Heeresgruppe A, advanced 310 miles (500km) in less than three weeks and suffered only 77,000 casualties. By 1945, the Red Army finally had the strength and experience to approach the kind of operational warfare that Tukhachevsky had envisioned in the mid-1930s.

Zhukov's two tank armies advanced eastward rapidly across the flat plains of Poland, preventing the Germans from re-forming a new line. This would have been an excellent opportunity for Zhukov to employ airborne units to seize critical river crossings and other key terrain ahead of the Soviet tank armies, but he had lost his enthusiasm for airborne operations after the failures at Vyazma in 1942 and Bukrin in 1943. Despite the onrush of Soviet armour, the Germans were able to gather about 45,000 troops in Poznan, sitting squarely on the main route to Berlin. Hitler declared the city a fortress

A German PzKpfw IV tank burns in the snow. Zhukov's Vistula–Oder Offensive quickly shattered AOK 9 and reached the Oder River. (From the fonds of the RGAKFD at Krasnogorsk via Nik Cornish)

and the encircled troops put up a desperate defence. Zhukov ended up committing the bulk of Chuikov's 8th Guards Army to reduce the fortress, which held out for a month.

Nevertheless, Zhukov was optimistic that he could reach Berlin quickly. Elements of General Nikolai Berzarin's 5th Shock Army reached the Oder River on the morning of 31 January and secured a small bridgehead at Kienitz, only 44 miles (70km) from Berlin. Berzarin grabbed two more small bridgeheads the next day and succeeded in pushing three infantry regiments across. There were no significant German forces in the immediate vicinity. Further south, the 8th Guards Army and the 69th Army secured small bridgeheads south of Küstrin and the 33rd Army crossed the Oder south of Frankfurt an der Oder. Zhukov issued orders to his subordinate armies on 4 February that they would capture Berlin in a *coup de main* by 15–16 February. At this point, the weather turned against Zhukov. A sudden thaw melted much of the river ice, making it impossible to get armour or heavy artillery across the river. The sudden advance of the Vistula–Oder

Breakout from the Magnuszew Bridgehead, 14 January 1945

Zhukov's *magnum opus* of World War II was not Moscow, Stalingrad or Kursk, but the relatively obscure Vistula–Oder Offensive of January 1945. In contrast to most of his other operations of the war, Stalin granted Zhukov the time to prepare a deliberate offensive carefully to smash the German defences in central Poland into dust. Unlike other Soviet offensives that had prematurely run out of steam only to be smashed by German counterattacks, Zhukov built up his 1st Byelorussian Front into an invincible battering ram, with large reserves of fuel and ammunition. Furthermore, Zhukov used his trademark *maskirova* (deception) tactics to conceal his force build-up in the Magnuszew and Pulawy bridgeheads over the Vistula from the German AOK 9. Indeed, the logistic planning for this offensive was one of the best conducted by the Red Army during the war and marked Zhukov as a superb tactician, when given the chance. Chuikov's 8th Guards Army was able to slice through the defences of the German 6. Volksgrenadier-Division in a matter of hours, providing Zhukov with a clean breakthrough into the depths of AOK 9's defences. The massive Soviet artillery preparation has shattered the trenches of German units which unwisely decided not to thin out their forward positions, resulting in heavy infantry losses. Here, a column of IS-2 heavy tanks (1) from the 67th Guards Heavy Tank Brigade, along with infantry (2), push through the shattered German positions, past destroyed assault guns (3) and AT guns (4), while dazed German POWs are roughly shoved toward the rear. Although a few T-34s (5) burn in the background, Soviet losses were unusually light on the first day. Overhead, YAK-9 fighters (6) provide air cover, preventing interference by the Luftwaffe.

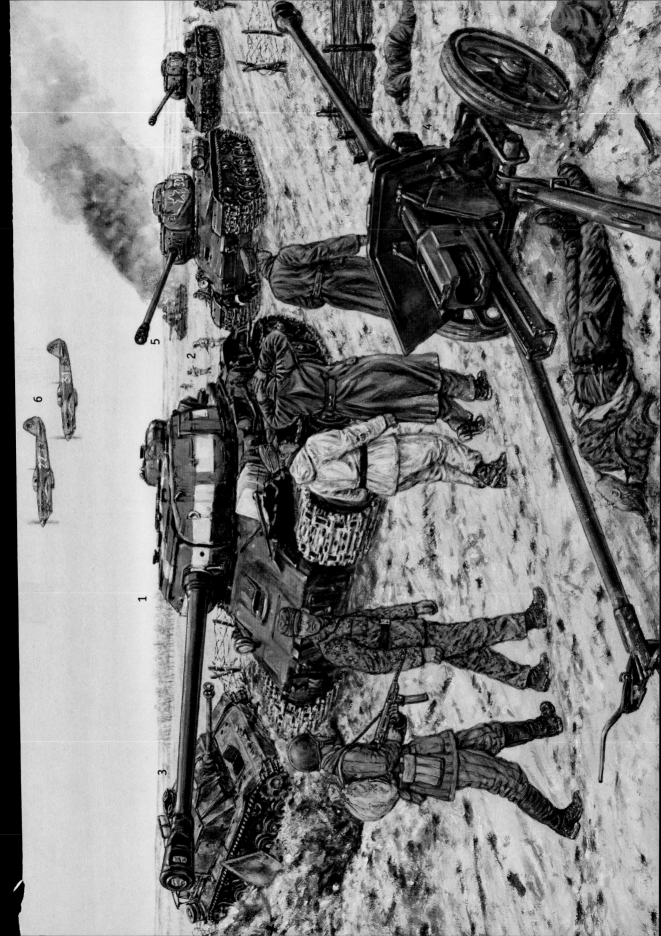

Offensive had also left Soviet air cover far behind and the Luftwaffe regained temporary air superiority over the Oder bridgeheads. The Luftwaffe attacked the bridgeheads mercilessly, inflicting considerable loss and provided enough of a delay for the OKH to shift two mechanized divisions hurriedly to counterattack the main bridgeheads. Furthermore, the Germans were able to get some troops to hold the vital fortress of Küstrin, just as Soviet troops reached the city outskirts. Although AOK 9 failed to reduce Zhukov's bridgeheads, Küstrin – which sat squarely between the Soviet bridgeheads over the Oder – held out until late March. Zhukov was forced to commit more troops into a protracted siege operation, further depleting his resources. It was not until early March that Zhukov was able to get a full tank corps across the Oder and by then, the Germans had reinforced the forces opposing him.

Further ending all hope for an immediate push on Berlin, a gap appeared between Rokossovsky's 2nd Byelorussian Front and Zhukov's 1st Byelorussian Front in East Pomerania, which the OKH quickly recognized. Hoping to conduct an enveloping attack against Zhukov's right flank, the Germans massed SS-Obergruppenführer Felix Steiner's AOK 11 near this gap between the two Soviet fronts. Steiner attacked on the morning of 15 February and his Panzer units achieved momentary success against the 61st Army, inflicting some losses and recovering a bit of ground. Losing ground to the Germans at this stage of the game was sure to raise Stalin's ire and Zhukov was forced to reorient both his tank armies and the 3rd Shock Army toward the north-west to deal with Steiner. Although the German attack quickly fizzled out, Zhukov was now committed to a major effort into East Pomerania and he decided to mount a joint operation with Rokossovsky

Soviet bridging operations became a critical enabler in 1944–45 in order to speed the advance across Poland and into Germany. The creation of engineer bridging units was just as important for the final Soviet victory as tank armies and artillery corps. (Courtesy of the Central Museum of the Armed Forces Moscow via Nik Cornish)

to crush the German 3. Panzerarmee and reach the Baltic shore. Fuel and transportation difficulties delayed Zhukov's offensive until 1 March but it quickly tore apart the 3. Panzerarmee and reached the Baltic three days later. However, German remnants clung to bridgeheads over the Oder near Stettin and Zhukov was not able to drive them across the river until 21 March. By this point, his 1st Byelorussian Front was depleted, short of fuel and ammunition and in need of regrouping, which gave the defenders of Berlin another short respite.

Marshal Zhukov takes a break with his mistress, Lieutenant Lidia Zakharova on the lake at Miedzychod in western Poland in late March 1945. He criticized other senior commanders for taking 'field wives' but failed to set the example himself. (RIA Novosti, 1989)

Operation *Berlin*, March–April 1945

In the pause following their defeat in the Vistula–Oder Offensive, the Germans hastily cobbled together Heeresgruppe Weichsel (Vistula) from remnants and training units to defend the new front on the Oder River. Initially, Hitler placed SS-Reichsführer Heinrich Himmler in charge of this ragtag formation but when he abandoned his command, he was replaced with Generaloberst Gotthard Heinrici on 20 March. Heinrici was chosen because he was a master defensive tactician and had held off Zhukov successfully before, at Vyazma in 1942. Although Heinrici's situation was desperate, with barely 200,000 troops in AOK 9 and 3. Panzerarmee, he still had some unpleasant surprises for Zhukov. Leaving Manteuffel's 3. Panzerarmee to defend the Oder front north of Berlin to the Baltic coast, Heinrici concentrated his best available resources

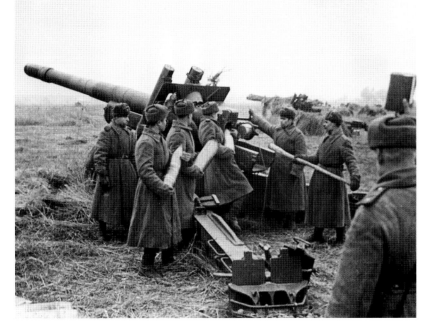

Zhukov massed an unprecedented amount of artillery for Operation *Berlin*, including super-heavy weapons like this 152mm ML-20 howitzer. Yet despite a massive artillery preparation, Zhukov's 1st Byelorussian Front took four days to break through the AOK 9 defences. (RIA Novosti, 623556)

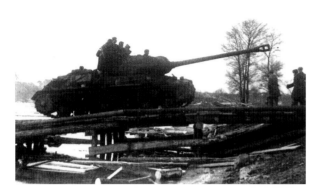

in the centre and built up a solid defensive position on the Seelow Heights that stood between Berlin and Zhukov's bridgeheads over the Oder. In the brief respite afforded by the East Pomeranian diversion, General der Infanterie Theodor Busse's AOK 9 built three lines of defence around the Soviet bridgeheads and laid thousands of mines. In addition, the Germans were aided by a very wet spring, which flooded the Soviet bridgeheads and turned the low-lying Oder Valley into a swampy morass.

A Soviet IS-2 heavy tank crosses an improvised wooden bridge during the advance into Germany. Zhukov's armoured force was vastly better in both quality and quantity than the hotchpotch tank outfits he relied upon in 1941–42. (From the fonds of the RGAKFD at Krasnogorsk via Nik Cornish)

After the conclusion of the East Pomeranian Offensive, Zhukov was called to Moscow on 29 March to plan the final offensive against Berlin. With the end of the war within sight, Stalin was beginning to have second thoughts about allowing Zhukov to reap all the glory of capturing Berlin. Instead, Stalin preferred a pincer attack by Zhukov's 1st Byelorussian Front against AOK 9 and Konev's 1st Ukrainian Front to crush 4. Panzerarmee in order to converge simultaneously upon Berlin from both the east and the south. Zhukov tried to prevent Konev from advancing into Berlin by quietly inserting a 'stop line' south of Berlin in the operational plan, but Stalin overruled that. Zhukov realized that this was going to be the last offensive of the war against Germany and in one of those moments where his ego got the better of his military judgement, he refused to share the final victory with his long-time rival, Konev.

Stalin believed that the Western Allies might disregard the Yalta agreements and advance upon Berlin, so he ordered the Stavka to execute

16 April 1945

1. 0300hrs: a massive – but largely ineffective – 30-minute Soviet artillery preparation begins against the German first defensive line between Wriezen and Seelow.
2. 61st Army's attempt to cross the Oder is easily contained by the 5. Jäger-Division.
3. The 1st Polish Army succeeds in crossing the Oder and advances 3 miles (4km).
4. The 47th and 3rd Shock Armies slowly shove their way through the first German defensive line and advance 5–6 miles (8–9km).
5. Zhukov's main effort, the 5th Shock and 8th Guards Armies, runs into stiff resistance from the German LVI Panzerkorps on the Seelow Heights and suffers heavy losses.
6. 1430hrs: in an effort to speed up the breakout, Zhukov commits the 2nd Guards Tank Army to support the 5th Shock Army and the 1st Guards Tank Army to support the 8th Guards Army. However, this only adds congestion and further hampers the Soviet main effort.

17 April 1945

7. The 25. Panzergrenadier-Division is committed to plug the gap left by the destruction of the 606. Infanterie-Division.
8. 3rd Shock Army crushes the 309. Infanterie-Division but has difficulty crossing the numerous canals.

9. 5th Shock Army makes the best progress and pushes the 12th Guards Corps as far as Neu Hardenberg. However, the Germans commit the 18. Panzergrenadier-Division to contain this Soviet success.
10. After slow progress all day, the 8th Guards Army finally takes Seelow.
11. Panzergrenadier-Division 'Kurmark' advances northward to reinforce the remnants of the 303. Infanterie-Division.

18 April 1945

12. The CI AK line of defence collapses under the onslaught of the 1st Polish Army and the 47th Army, but the Germans manage to hold onto Wriezen until nightfall.
13. The 2nd Guards Tank Army and 5th Shock Army advance into a gap in the German lines near Batzlow but lead elements of the 11. SS-Panzergrenadier-Division 'Nordland' arrive just in time and inflict heavy losses.
14. The 8th Guards Army overruns LVI Panzerkorps' second line of defence (Stein Stellung) but is halted short of the third line (Wotan Stellung).

19 April 1945

15. The 8th Guards Army captures Müncheberg by 1800hrs, splitting the final German defensive line.

Breakout from the Oder River bridgeheads, 16–19 April 1945

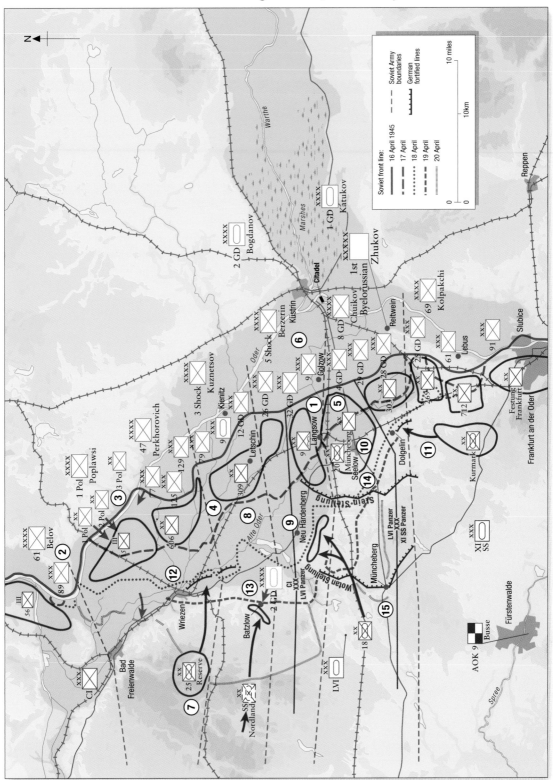

Operation *Berlin* no later than mid-April. Consequently, Zhukov and Konev had less than two weeks to plan a multi-front offensive involving over 1.4 million troops. Zhukov did a superb job cramming 41 of his 79 divisions into the bridgeheads over the Oder and rushing forward all available artillery to support the offensive. He used the Vistula–Oder Offensive as a template for planning Operation *Berlin* and expected this attack to proceed just as smoothly. Zhukov massed an unprecedented 6,464 artillery pieces and 1,078 rocket launchers in the sectors of his four main assault armies, anticipating that a huge 30-minute artillery bombardment would obliterate the front-line German defences. However, the hasty Soviet preparations had not allowed sufficient time for reconnaissance to detect all the concealed German defences and Zhukov failed to account adequately for either Heinrici's defensive tactics or the miserable weather and terrain. Unlike the Vistula–Oder Offensive, Zhukov could not deceive Heinrici about where the blow was to fall and, weak as they were, the Germans were alert. Learning from the debacle in Poland, Heinrici decided to thin out his front-line trenches just before the Soviet artillery preparation began in order to minimize casualties.

Zhukov began two days of aggressive probing along the 25-mile (40km) front of his bridgeheads over the Oder River on 14 April, as a prelude to his grand offensive. For his last offensive, Zhukov planned to do something risky and unusual in order to gain surprise – a night attack. He brought in a large number of searchlights, which he wanted to illuminate the German positions once the attack began. At 0300hrs on the morning of 16 April, Zhukov unleashed perhaps the largest artillery bombardment in the history of warfare upon AOK 9. Some 8,983 artillery pieces and 1,401 rocket launchers fired for 30 minutes. However, Heinrici's temporary evacuations greatly reduced the

Soviet infantry advancing into a German city. Zhukov made little or no effort to curb the looting, raping and murdering committed by his troops in Germany. (Courtesy of the Central Museum of the Armed Forces Moscow via Nik Cornish)

result of the Soviet bombardment. At 0320hrs, the infantry of the 1st Polish, 47th, 3rd Shock, 5th Shock, 8th Guards and 69th Armies all began to advance, but the searchlights ended up depriving many of the Soviet troops of their night vision and caused considerable confusion. Zhukov's plan was also based upon a faulty assessment of the terrain and the depth of the German defences. At the opening of the battle, Zhukov was in Chuikov's command post atop the Reitwein spur, but he could not see that the Soviet assault groups were suffering heavy losses and were having great difficulty crossing the numerous water obstacles in the area. The German LVI Panzerkorps, atop the Seelow Heights, virtually stopped Zhukov's main effort – Chuikov's 8th Guards Army – dead in its tracks. Although the 1st Polish and 47th Armies enjoyed some success in the north, the rest of Zhukov's armies had to smash their way through one German defensive line after another. Amazingly, even extemporized units such as the 303. Infanterie-Division were able to hold their ground against the all-out Soviet offensive.

Zhukov visiting the ruins of the Reichstag after the fall of Berlin. Note the presence of Lidia Zakharova again (right). (Courtesy of the Central Museum of the Armed Forces Moscow via Nik Cornish)

Zhukov added to his catalogue of planning errors by committing both his tank armies into the fray on the evening of the first day, even though the German lines were unbroken. The premature commitment of these two tank armies into an already crowded battle area only resulted in further confusion and heavy Soviet losses. It took Zhukov's armies four days of bitter fighting and 33,000 dead, until they finally overcame the German defences and broke AOK 9's front. Severe ammunition shortages undermined the German defence which otherwise, might have held at least some sectors. Zhukov's conduct of the battle of the Oder was abominable and Stalin took notice. In contrast, Konev's 1st Ukrainian Front had broken through 4. Panzerarmee to the south with relative ease and Stalin authorized him to turn north and head for Berlin. Having lost a considerable part of his infantry and one-third of his armour just in the first four days of his offensive, Zhukov's front was in poor shape for an immediate attack into Berlin but he was not going to allow Konev to beat him there, either. Instead, he swung the 2nd Guards Tank Army and 3rd Shock Army to envelop the city from the north, while advancing directly on Berlin with 5th Shock Army, 8th Guards Army and 1st Guards Tank Army. In his haste to get to Berlin, Zhukov permitted a large part of the battered AOK 9 to escape into the wooded Spreewald south-east of Berlin, Even though AOK 9 was soon caught between Konev's and Zhukov's forces, it conducted an incredible – although very costly – fighting withdrawal toward the American forces on the Elbe River.

Meanwhile, Zhukov's forces arrived in the northern and eastern suburbs of Berlin on 22 April, just as Konev's forces were coming in from the south-west. The Stavka had authorized Konev to move into the city without

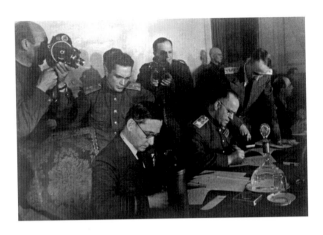

Zhukov signing the German surrender document for the Soviet Union in Berlin on 8 May 1945. Zhukov was at the zenith of his wartime prestige but his moment of glory was fleeting. (RIA Novosti, 534886)

informing Zhukov – a clear sign of his diminished status – and he did not become aware of this until some of his tankers bumped into Konev's advance guard. In his rush to get to the Reichstag before Konev, Zhukov pushed armour into the city with inadequate infantry support, which resulted in heavy tank losses to Panzerfaust-equipped Volksturm units. Even though the German defenders were pathetic, ill-equipped remnants, Zhukov's hasty attack into the city centre afforded them one last opportunity to inflict painful losses on the Red Army. Many Russian casualties were also caused by fratricidal artillery bombardments resulting from the poor coordination between Zhukov's and Konev's converging forces. Both fronts spent the next nine days crushing the desperate German resistance, until the final collapse. Zhukov's troops won the race to the Reichstag, where they raised the Soviet banner on 1 May.

OPPOSING COMMANDERS

During the course of World War II, Zhukov commanded Soviet forces in a dozen distinct campaigns and achieved a clear victory in seven of these operations. He achieved a draw or incomplete victory in three campaigns (the defence of Leningrad, the Moscow counteroffensive and Kamenets-Podol'skiy). Despite post-war claims that he was a general 'who never lost a battle', Zhukov suffered one clear defeat against Walter Model at Rzhev in November 1942. Nevertheless, a 7-3-1 track record was an impressive accomplishment for any general of World War II, particularly a Soviet one.

Zhukov went up against a dozen German senior commanders in 11 campaigns on the Eastern Front. Although far less well-trained than the *Herren* like Leeb, Bock and Kluge he went up against in 1941–42, he was 15 years younger than each and toughened by the Stalinist purges. These commanders had far greater General Staff experience than Zhukov and were more well rounded as senior officers. Yet unlike the German army group commanders who questioned Hitler's orders, Zhukov was totally obedient to Stalin and the Stavka, who could rest assured that Zhukov would carry out their directives no matter what the cost. As a committed Communist, political imperatives trumped military logic. To his old school opponents this kind of thinking was anathema, which made them vulnerable to his relentless style of warfare. Unaccustomed to an opponent who would continue attacking in sub-zero weather to the last tank and rifle squad, they wilted and asked for relief. To his credit, Zhukov never shrank from a task, although he did prefer tasks that kept him in the limelight and enhanced his reputation.

However, Zhukov began to run into a new type of German commander in 1942–43, who was younger, tougher and had plenty of battlefield experience. Opponents such as Walter Model, Gotthard Heinrici and Hans-Valentin Hube were still eight to ten years older than Zhukov, but each had commanded divisions, corps and armies in combat. They had gained the measure of their Soviet adversaries and proved extremely tough as opponents. Model inflicted the worst defeat on Zhukov at Rzhev in 1942 and parried his blows in the north Ukraine in 1944. Heinrici also proved his ability to inflict serious losses on Zhukov at Vyazma and then the Seelow Heights. All three of these new-style German commanders had learned tactical methods to mitigate Soviet offensives and could deny Zhukov success until the overall odds shifted overwhelmingly in his favour. For his part, the fact that he never commanded tactical formations in modern combat conditions proved detrimental to Zhukov's development as a commander, since he proved unwilling to learn either from his enemies or from capable subordinates such as Simoniak or Katukov. Although he became increasingly adept at using the tools that the Stavka provided him, Zhukov never introduced any important tactical innovations to assist the Red Army's advance westwards or reduce his own casualties. Thus, although these late-war German commanders lacked the resources to stop Zhukov's inexorable advances, they had an edge over him in terms of tactical innovation that enabled them to frustrate or delay his plans on occasion.

WHEN WAR IS DONE

Although Germany surrendered at Rheims on 7 May 1945, Stalin demanded another official surrender ceremony in Berlin two days later, with Zhukov signing for the Soviet Union. Zhukov was briefly involved in post-war occupation policies in Germany and was the first Soviet member on the governing Allied Control Council. Although he had often disparaged Allied contributions during the war and had no previous experience with foreign officers, Zhukov now came into regular contact with American, British and French military leaders. He professed great admiration for General Eisenhower and bent over backwards to establish a personal friendship with the American commander.

In mid-June 1945, Zhukov was recalled to Moscow in order to participate in the Soviet Victory Parade. Rokossovsky commanded the parade on 24 June and Stalin allowed his wartime deputy to take the salute. Returning to Berlin, Zhukov was the host for the Potsdam Conference in July, where Stalin

Zhukov with Montgomery, Eisenhower and de Lattre de Tassigny in Berlin on 5 June 1945. Although he tried to develop a personal bond with Eisenhower, Zhukov's brief foray into international diplomacy only increased Stalin's suspicion about his intentions. (From the fonds of the RGAKFD at Krasnogorsk via Nik Cornish)

and President Truman discussed post-war plans. Instead of playing any significant part in the discussions, Zhukov invited Eisenhower to visit Moscow in August. In discussions with Zhukov, Eisenhower noticed that Zhukov had very little personal autonomy and had to refer even minor matters to Stalin for approval. Eisenhower reciprocated by inviting Zhukov to visit the United States, but Stalin refused permission. With the war over, Stalin now regarded Zhukov as just another one of the 'little screws and bolts' that made up the greater Soviet enterprise and he moved quickly to demote him from his wartime deputy role. In April 1946, Stalin called Zhukov back from Germany and replaced him with his ever-present chief of staff, Vasily Sokolovsky.

Returning to Moscow to meet with the Main Military Council in June 1946, Zhukov found himself entering a lion's den and was accused by Stalin, Molotov and Beria of being politically unreliable and relieved as Commander-in-Chief of Soviet Ground Forces. Of the military officers present, including Konev, Rokossovsky and Vasilevsky, only Pavel Rybalko protested about Zhukov's abrupt removal. Stalin was beginning a new purge of the Soviet High Command after the victory and Zhukov was his first victim, although he was too high profile to execute or imprison. Instead, Stalin sent him into internal exile by assigning him to command the backwater Odessa MD. Under great stress as 'an enemy of the Central Committee', Zhukov suffered a heart attack in January 1948. When he recovered, he was shuffled off to an even more obscure posting as commander of the Ural MD. It must have been heart-rending for a man who had commanded millions just a few years before to be now assigned to such inconsequential posts while Konev, Rokossovsky and Vasilevsky held key posts. However, he managed to console himself with a new mistress, another young medical officer named Galina Aleksandrovna who was treating his heart condition.

After seven years in obscurity, Stalin's death in March 1953 changed everything. Nikita Khrushchev brought Zhukov back as Deputy Minister of Defence to help him remove Beria. Zhukov led the military detachment that arrested Beria, after which he was tried and executed. For this demonstration of personal loyalty to Khrushchev, Zhukov was given a prominent role in supervising the modernization of military power. Khrushchev was eager to deploy nuclear weapons as quickly as possible in order to match the Americans, but the programmes were dogged by delay and inefficiency. Zhukov seemed the logical choice to jumpstart the Soviet nuclear programme. On 14 September 1954, Zhukov was in charge of Exercise *Snezhok* (Snowball) at Orenburg, where a 40-kiloton nuclear weapon was tested under simulated battlefield conditions involving 45,000 troops. Although Zhukov proudly reported the successful test back to Khrushchev, *Snezhok* proved to be one of the worst environmental disasters

After a brief spell in occupied Germany, Zhukov was brought home and demoted to command of the backwater Odessa MD. Here, he is seen observing troop training in March 1947. (RIA Novosti, 059188)

in post-war Soviet history and thousands were needlessly exposed to harmful doses of radiation.

In 1955, Premier Nikolai Bulganin appointed Zhukov as his defence minister. Although this appeared to be the professional pinnacle of Zhukov's military career, it was in fact his swansong. Zhukov became more involved in political issues, supporting Khrushchev in ousting Molotov and other Stalinist-era holdouts. Yet when it came to military matters, Khrushchev disregarded most of his recommendations and it was equally obvious that Zhukov was out of step with the defence policies of the new regime. Whereas Zhukov still believed in large conventional armies, Khrushchev preferred a cheaper defence structure based upon strategic nuclear weapons in order to free up resources for rebuilding the Soviet civilian economy. Zhukov had little understanding of Cold War strategy or economics, but he made the mistake of resisting Khrushchev's cost-cutting measures to trim the Red Army.

Like all Soviet leaders, Khrushchev wanted the Red Army to be a subservient tool of the CPSU and, with Stalin and Beria gone, Zhukov was becoming more independent. Khrushchev dispatched Zhukov on a rare diplomatic trip to meet with Tito in Yugoslavia and while he was out of the country in October 1957, he was not only relieved of his position as defence minister but expelled from the party's Central Committee. Normally, Soviet marshals were transferred to the Group of Inspectors so they could keep some senior officer perks but Zhukov was forced into retirement. Shortly afterwards, Konev wrote a highly critical article in Pravda about Zhukov, with the obvious endorsement of the party. Zhukov retired to his dacha outside Moscow intending to write his memoirs, but the party forbid it. Adding insult to injury, Chuikov published his own memoirs in 1964, which further tarnished Zhukov's wartime accomplishments. However, after Khrushchev was removed, Leonid Brezhnev decided to partly rehabilitate Zhukov by inviting him to attend the 20th anniversary celebration parade for the German surrender. Afterwards, Brezhnev allowed Zhukov to write his memoirs, as long as he inserted some fabricated sections about Brezhnev's own wartime role. Zhukov spent the last 17 years of his life focused inwards, on his family and his memoir writing, until his death in 1974.

INSIDE THE MIND

Zhukov spent the bulk of his early military career in a close-knit cavalry community and under the thumb of political commissars who could send any man off to the Lubyanka Prison or worse with just a word. These environmental factors shaped Zhukov into an officer who focused on accomplishing assigned tasks quickly and efficiently, as well as being very aware of the repercussions of failure. He was trained by a system that viewed human lives as an expendable commodity and the only loyalty of any

importance was obedience to Stalin. Traditional military values, such as loyalty to one's unit or comrades, were never imprinted on his psyche.

Although he professed admiration for the theories of Tukhachevsky and Uborevich, Zhukov was not an intellectual or military theorist and viewed deep battle merely as a pragmatic tool. He was attracted to the potential of tanks and paratroopers to assist breakthrough attacks and was receptive to using them at the forefront of his operational plans, but never took the time to understand their unique limitations. He also embraced the concept of *maskirovka*, in concealing his intentions from the enemy. Throughout his career, Zhukov never developed any specific doctrines or tactical innovations but borrowed existing methods.

Once he rose to the General Staff, Zhukov proved to be a fish out of water, with little head for strategic planning. He left the bulk of detailed planning to professional staff officers like Shaposhnikov, Vasilevsky and Antonov. Instead, Zhukov focused on making recommendations to the Stavka about where and when to conduct offensives. As a Stavka representative, flying from front to front, Zhukov felt little attachment to the armies that were temporarily placed under his command and felt no remorse about expending other generals' troops as cannon fodder. In general, he was aloof towards most of the officers under his command and made very little effort to know or understand the plight of the average Soviet soldier.

Zhukov's main contribution during 1941 was his stubborn refusal to admit defeat or panic in the face of remorseless German advances. He was at his absolute best in a crisis. The Wehrmacht had never run into this type of enemy commander before, who didn't wilt before the blitzkrieg. Zhukov's courage and innate stubbornness proved to be one of the major factors in steadying the Red Army in the winter of 1941–42. However, Zhukov's stubbornness proved a debit in 1942–43, when he refused to admit that attacks at Rzhev had failed and continued to throw more divisions into the German buzz saw.

As a front commander, Zhukov usually shuffled between lower headquarters in order to browbeat his subordinates into moving 'faster'. The Stavka viewed him as a ramrod who ensured that directives were carried out. His bullying methods worked with most subordinates except for tough front-line commanders like Simoniak, who simply ignored his threats. Zhukov rarely went closer to the front than division-level command posts and he often functioned more as a 'resource manager' than a front-line commander. He felt little need or compunction to be tactically innovative as long as he was supplied with masses of troops, equipment and supplies, although some subordinates resented his profligate attitude toward expending the lives of their troops. Zhukov's offensives had a median 13 per cent fatality rate for his committed troops, compared with 7–8 per cent for Konev, Vatutin, and Rokossovsky. Simple things, like task organizing shock groups to include combat engineers to clear enemy minefields, did not interest him until late in the war. Zhukov later shocked Eisenhower with his discussion about intentionally marching troops through

Soviet front commanders in May 1945. From left to right front row, Marshals Ivan Konev, Alexander Vasilevsky, Georgy Zhukov, Konstantin Rokossovsky and Kirill Meretskov. Left to right background, Fedor Tolbukhin, Rodion Malinovsky, Leonid Govorov, Andrei Eremenko and Ivan Bagramyan. (RIA Novosti, 90221)

minefields in order to save time – although this was partly boasting to impress a foreign officer.

Zhukov had absorbed enough about the theories of deep battle from Tukhachevsky and Partial Victory from Uborevich to understand the methods necessary to defeat the Wehrmacht in Russia. Throughout the war, Zhukov focused his energies on conducting enveloping attacks against vulnerable German-held salients, anticipating that a series of such victories would lead to a widespread collapse of morale. While his early efforts to encircle German forces were sound at the operational level, they were marred by inadequate tactical execution, which was partly his fault. At Rzhev, he never visited the critical penetration sectors to ensure that his infantry had the necessary resources and tactics to breach the main German line of resistance successfully. At Korsun and Kamenets-Podol'skiy, he was a bit too mesmerized by the ability of his tank corps to accomplish an encirclement, without appreciating that they lacked the infantry to contain the trapped German forces. Although he expended great effort on managing fuel and ammunition supplies – in line with the Communist theories of war he learned at the Frunze – he never spent any significant effort to improve the quality of training the Red Army received. Zhukov's operational methods were based upon careful, deliberate planning and thorough logistic preparation. For Zhukov, the most important principles of war were surprise, mass, offensive and objective and his thinking was conditioned by the Bolshevik credo that nothing was impossible with sufficient expenditure of lives and resources.

Like other Soviet commanders, Zhukov was enough of a military professional to prefer carefully planned set-piece offensives but with Stalin and Beria breathing down his neck, he knew that political imperatives trumped military science. As someone who had dodged the bullet during the purges of 1937–41, Zhukov was in no mood to risk his life by openly challenging Stalin on the conduct of the war. Consequently, Zhukov often knuckled under and conducted hasty offensives in 1941–43 to satisfy

Kremlin demands, but which resulted in negligible gains and heavy losses. Zhukov's relationship with Stalin worked as long as Zhukov understood his place as a military adviser but tended to break down – as it did over Kiev in 1941 – when Zhukov tried to push through decisions based solely on military logic. After the battle of Moscow, Zhukov's relationship with Stalin became every bit as servile as that of Jodl and Keitel with Hitler. It was not until 1944 that Zhukov finally had the latitude to conduct the kind of operations he preferred and his abilities as a commander were more evident in the Vistula–Oder Offensive.

As an officer, Zhukov demonstrated little loyalty to his subordinates and instead openly vied with Rokossovsky and Konev for greater recognition. He flagrantly stripped resources from other fronts to bolster his own operations and consciously sought the limelight. Zhukov not only wanted the Soviet Union to win, but he wanted to be seen as the primary architect of that victory. He was also far more involved with Kremlin politics than any of his peers and he accepted the Stalinist notion that truth was a malleable concept. Ultimately Zhukov became too involved in the Kremlin power game, which proved his undoing. He could be very emotional at times and was a serial adulterer, both of which were kept from the public eye. Although Zhukov's victories at Khalkhin-Gol and the Vistula–Oder were among the most impressive accomplishments by the Red Army during the war, his personal flaws exclude him from the ranks of the great captains.

A LIFE IN WORDS

Zhukov's memoirs appeared as *Reminiscences and Reflections* in February 1969. The initial version of his memoirs was heavily censored by the Brezhnev regime, avoiding overt criticism of Stalin and following the standard Communist-era historiography of the Great Patriotic War. Defeats such as Operation *Mars* were entirely omitted and Zhukov denied that any significant number of Germans escaped from the Korsun Pocket. The memoirs sold briskly in Moscow and within a few years, appeared in an English translation in the West. As a piece of historical writing, Zhukov's memoirs are badly flawed by a combination of Communist wartime propaganda and the author's efforts to exaggerate his own infallibility. In 1972, a second edition of the memoirs was published in Moscow, with significant changes because of political concerns. The Brezhnev regime was willing to use Zhukov's memoirs as a tool to polish the image of the great victory over Fascism, as long as it was clear that victory was due to the collective wisdom of the party and not the skill of one general.

In Russia, Zhukov's image was generally positive until his dismissal. Then wartime rivals such as Konev, Rokossovsky and Chuikov savagely attacked Zhukov's reputation, in order to further the party's goal of reducing his stature. Criticism also began to appear from below, such as the Ukrainian

General-Major Pyotr Grigorenko, who served under Zhukov as a staff officer at Khalkhin-Gol, describing him as a 'cruel, vengeful person' who 'did not care about any losses we suffered'. Although many Red Army veterans continued to regard Zhukov as the 'organizer of victory', the relentless efforts by the CPSU to minimize his wartime contributions gradually chipped away at his once iconic image.

In the West, much of the historiography of Zhukov has been based upon his self-serving and politically biased memoirs, as well as wartime Soviet propaganda. The fact that Zhukov actually held no active commands in 1943 and spent much of the war without a permanent staff of his own, has slipped off the historical radar screen. After his death, Zhukov was mythologized as 'the general who never lost a battle' and his advisory roles at Stalingrad and Kursk were elevated to full responsibility. In the late 1960s, British historians wrote that Zhukov's 'record of success was on a scale unmatched by any other general in any army throughout the war'. The dark side of Zhukov's character – the death threats and the disregard for his own casualties – was as yet, unknown in the West. However, once Glasnost was introduced in the late 1980s and Soviet-era archives began to open up, Zhukov's reputation began to suffer. In 1999, the stalwart American historian David M. Glantz used newly uncovered materials to write *Zhukov's Greatest Defeat: The Red Army's Epic Disaster in Operation Mars*, which finally blew the lid off Zhukov's image of infallibility. Yet a 'cult of Zhukov' still persists in the West and to a lesser extent in Russia and even the distinguished British historian Simon Sebag Montefiore recently claimed that Zhukov was 'the greatest captain of the Second World War'.

BIBLIOGRAPHY

Chaney, Otto Preston, *Zhukov* University of Oklahoma Press, 1996

Coox, Alvin, *Nomonhan: Japan Against Russia, 1939* Stanford University Press, 1990

Glantz, David M., *Zhukov's Greatest Defeat: The Red Army's Epic Disaster in Operation Mars, 1942* University Press of Kansas, 1999

Grigorenko, Pyotr, *Grigorenko Memoirs* W. W. Norton and Co., Inc., 1980

Isaev, Sergei I., *Vekhi frontovogo puti: Khronika deiatel' nosti Marshala Sovetskogo Soiuza G. K. Zhukova v Velikoi Otehestvennoi voiny 1941–1945 gg* [*The Landmarks of a Front Path: A Chronicle of Marshal of the Soviet Union G. K. Zhukov's Activities During the Great Patriotic War 1941–1945*], VIZh, No. 10 (October 1991)

Krasnov V., *Zhukov: Marshal Velikoj imperii* Olma Press, 2005

Le Tissier, Tony, *Zhukov at the Oder: The Decisive Battle for Berlin* Stackpole Books, 2009

Mezhiritzky, P.Ya., *Reading Marshal Zhukov* Philadelphia: Libas Consulting, 2002

Rokossovsky, Konstantin, *A Soldier's Duty* Moscow: Olma Media Group, 2002

—, *Velikaia bitva na Volge* Moscow: Voenizdat, 1965

Spahr, William, *Zhukov: The Rise and Fall of a Great Captain* Presidio Press, 1995

Zhukov, Georgy K, *Marshal Zhukov's Greatest Battles* Cooper Press, 2002

—, *Memoirs* Jonathan Cape Ltd, 1971

INDEX